Wild Wheels

by Harrod Blank

Wild Wheels

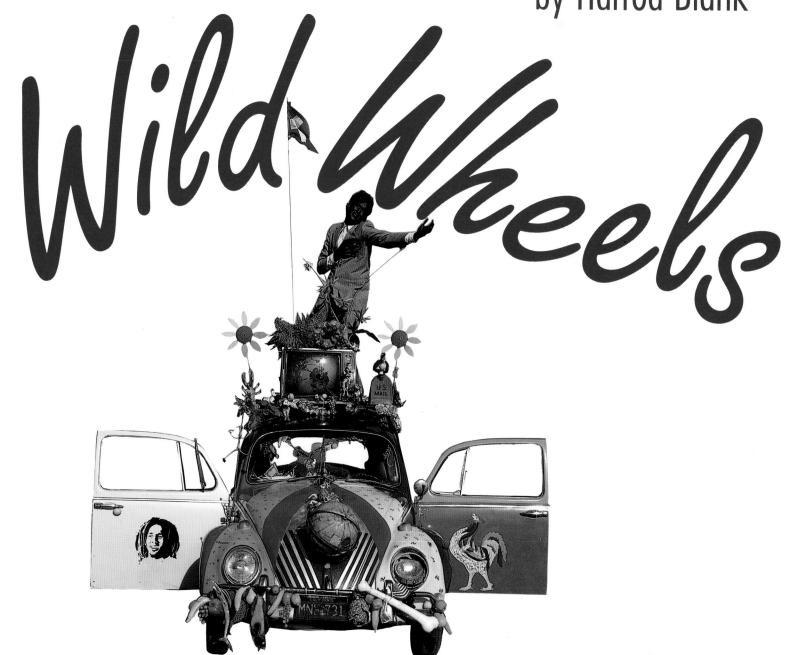

BLANK BOOKS Berkeley

Wild Wheels

First edition published by
Pomegranate Artbooks
ISBN 1-56640-981-0

Second editon / September 2001

Published by
Blank Books
2248 Summer Street
Berkeley, CA 94709

ISBN 0-933621-68-X
Library of Congress Card
Number 2001116982

Designed by Bonnie Smetts Design

Cover design by FERDwERKz

Printed in Korea

11 10 09 08 07 06 9 8 7 6 5 4

SECOND PAPERBACK EDITION

Contents

I was born in 1963 in Westminster, California, and lived in Woodland Hills until I was six years old, when my mother and father separated. My mother moved my brother and me to a commune in the Bonny Doon mountain region of Santa Cruz, a tourist town of 50,000 people. This is significant because I grew up in a forest and there were hardly any people around. I developed a feeling of alienation from people and an expertise with chickens. Spending a lot of time in the chicken coop didn't help me learn social skills, but it did make me think a lot about my identity.

When I attended Santa Cruz High School I was given the nickname of "Chickenman," and on a couple of occasions I actually took a pet chicken to school. I

liked the attention of standing out, even though it made it more difficult to fit in.

When I was seventeen our family moved from the forest to downtown Santa Cruz. I brought my chickens and built a chicken coop, but it wasn't the same. The neighbors complained about the roosters, and there was no forest to run through; no secret hideouts to hang out in; and no lizards, snakes or bugs to play with. Eventually I was forced to give up the chickens and spend more time with other friends.

I developed a passion for reggae music, especially songs about chickens, and began a collection that would surpass 100 albums in a matter of months. I had made some friends by that time, and we frequented reggae concerts and caused havoc like most teenagers. Then when it came time to drive, my life changed drastically.

I bought a 1965 all-white VW bug for $600 from Mark Levy, a ceramics teacher at the high school. I drove it around, but it was the most boring car in the world. I felt different, but my car wasn't different. I wanted to stand out again, like a rooster, bright and colorful.

Two influences in particular led me to begin making an art car. One was a book I read about Native American philosophy called *Seven Arrows*. I was completely enthralled by the fact that people in the tribe put medicine wheels near the entrances to their teepees. Through symbolic pictures and writing, the

Introduction

wheels described who lived inside. I thought it was a healthy way to live, to be honest about oneself and then to share it with the community. The other influence was a movie I saw called *The Harder They Come*, a film starring reggae king Jimmy Cliff. There was this guy in the movie who had a motorcycle, and on its gas tank was a hand-painted Lion of Judah. He was really cool, and everywhere he went he was recognized for his unique motorcycle. I believe that was the first art car/motorcycle I had ever seen.

Some time after seeing the film my friend Kevin Ratliff and I began painting my VW bug with spray paint, adhering to a reggae theme. Over the course of a couple

of years, we painted the hood fluorescent green and the passenger's side red, gold and green, and we put a candy cane-colored tube over the antenna. I painted a portrait of Gregory Isaacs, a reggae star, on the driver's door, and two other friends painted a portrait of Bob Marley on the passenger's

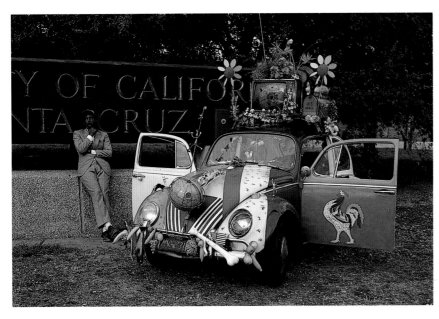

door. We called it the "Rasta Bug."

I was amazed at how much attention the car attracted and how many people wanted to ride in it and be associated with it. Wherever my friends and I went, I drove—always. It even became a big hit among many friends and acquaintances to have sex in the car. Everyone knew how to break in

by opening the wing-wang window, and putting the seats back was common knowledge. By the time I graduated from high school, virtually all of my friends could brag that they had had sex in the "Rasta Bug." Kevin had a tally of his own going that he scratched into the paint above the visor for every girl he had messed around with in the car. I, on the other hand, was still a virgin trying to figure out how to relate with girls.

By the time I entered college at UC Santa Cruz in 1981, I had a reputation for being the guy who drove that crazy car. I did meet a lot of women, but none that seemed totally comfortable riding around in the "Rasta Bug." All of my friends knew I was a virgin, and whenever we went out, they put a tremendous amount of pressure on me to get laid. I didn't want to get laid; I wanted to be loved. I often went home early from parties or dances to study or to work on the car. Since I didn't have a garage, I would drive downtown and park under a two-story parking lot where there were lights. I would stay up for hours painting, gluing and dumping my love into the car. I often told myself that if I couldn't love a woman, I might as well love my car.

Then in 1984, at the age of twenty-one, I went to Mexico City to study for a year. Actually, my main interest in making the trip was to follow a woman I was interested in. The year was a rough one, and to make a long story short, I had two guns put to my head, I was bitten by a dog and the woman I followed found another man. I did, however, lose my virginity on the island of Cozumel.

My year in Mexico had a big influence on me. When I returned to the States, I began painting the "Rasta Bug" with bright, gaudy colors and adding objects like bones, trophies and a world globe as a hood ornament. I painted over the portrait of Gregory Isaacs on the driver's door with a large painting of a rooster to represent my past. I also began experimenting with lights because a lot of the buses in Mexico had strings of purple lights inside of them.

I learned from studying anthropology in Mexico that there were two things the earliest humans responded to in the wild: color and movement. I decided to make as many objects on the car move as I could. I added two spinning yellow plastic sunflowers, a Swiss flag attached to a six-foot springy flag-

pole, pieces of fruit that dangled from the bumpers and all sorts of doodads that moved in the wind.

The "Rasta Bug" went through so many changes that the name didn't seem to fit anymore. One day when Kevin and I were sitting in the car by the lighthouse, one of our hangouts, several tourists came up and they all said, "Oh my God, what is this?" Kevin turned to me and said, "That's what you should call the car, 'Oh My God!'" I agreed, and the name has stuck ever since.

After being rejected by the creative writing program at UC Santa Cruz, I changed my major to theater arts with an emphasis in film. For my senior thesis I made a film called *In the Land of the Owl Turds* about my pursuit of the "right" woman, in which "Oh My God!" plays an important role. When I fail to find love, I dye myself green to depict feeling like an alien. The film received many awards and convinced me to be a filmmaker.

Finally, I graduated with a degree in theater arts. I showed up green at the ceremony in protest of the insidious requirement that I dress in a suit or traditional cap and gown. The chancellor almost didn't shake my hand after handing me my diploma.

Due to the success of *Owl Turds,* which was nominated for a Student Academy Award and played in the Berlin International Film Festival, I thought I was off and running. I spent seven months writing a script for a feature called *Broke Dick Dog* about interracial relationships and sex in the '90s. I

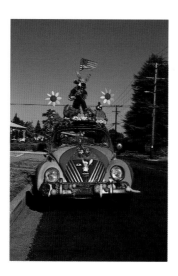

tried to find the money to have it produced, but no one wanted to take a chance on it. As a result, I tried to raise the money myself by painting a house and by not paying rent. I lived in my car and in a doghouse for three months, and as a result of a cold winter, I developed walking pneumonia and almost died. A girlfriend at the time, Angelle Pryor, nursed me back to health in January of 1989, and the

day I recovered I embarked upon the making of *Wild Wheels.*

In 1988 photographer Liz Zivic came to a screening of *Owl Turds* when it played at the Roxie Theater in San Francisco and expressed an interest in taking pictures of "Oh My God!." After several photo sessions, we decided to collaborate on a photo project on car art. I had accumulated a big list of people across the nation who had made art cars. Many tourists who saw my car told me about art cars in their hometowns. The first art car Liz and I photographed was the "Whale Car," which was featured in *Owl Turds* and was a Santa Cruz local.

After photographing dozens of art cars over a period of two years, Liz and I decided to make a calendar. I wrote to about fifteen different calendar companies, and Pomegranate was the only one that expressed an interest. They came out with *Art on Wheels* in 1991.

I used the calendar to help make the film by showing it to investors. Raising money for *Wild Wheels* was easier than my previous efforts because I had strong visuals instead of simply a script. I presented the calendar to the investors along with a super slide

show that Liz and I had designed together. If I got a meeting with some wealthy individuals, I was 90 percent sure that they would invest because they had never seen an art car before—and they were impressed. I also sold copies of the calendar provided by Pomegranate, and I used that money to buy film stock.

I tried to get a grant to make *Wild Wheels* and applied for many, but all rejected my proposals except one. Suzanne Demchak Theis was instrumental in helping me get a grant from the Houston International Festival, which cosponsors, with the Orange Show Foundation, Roadside Attractions: The Artists Parade (the biggest event for car art in the world). She gave me names and addresses for most of the art cars in Texas, and she has invited me to participate in and film every Roadside Attractions parade since.

The film crew, at any one time, consisted of myself and one or two others, and that was it. David Silberberg, now in the process of making his own film on what motivated "Oh My God!," helped the most, doing everything from sound recording and camera work to writing the narration and cutting the soundtrack. Others in the crew included my friend Kevin Ratliff; my father, Les Blank; Paul Cope; Liz Zivic and many others.

Wild Wheels took three solid years to make; a year and a half of that was spent in the editing room. It was very difficult to bring thirty-seven different artists together and make a film that is coherent and entertaining. As a result, a lot of great information and anecdotes were cut out. Through this book I have another chance to flesh out some of the characters of *Wild Wheels* and introduce you to some new ones. I hope you enjoy the ride!

Wild Wheels

At age sixty-five Jesselyn Zurik began the arduous task of gluing thousands of strands of Mardi Gras beads onto a 1974 Gremlin. Born and raised in New Orleans, Louisiana, and married to an ear, nose and throat specialist, she had plenty of time to spend on creating

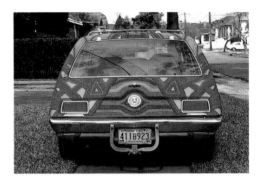

BEADED BUG

Jesselyn Zurik

art, which usually consisted of decorative wall hangings made of finely sanded driftwood. Wanting to do something different from her work with wood, something nobody had ever done before, she came up with the idea of covering a car with Mardi Gras beads.

The project actually began with a model Jesselyn designed for a model car show. Her model was

selected as one of the five best, and as her prize she was funded to make her model into a life-sized car. Initially she wanted to put beads on a VW bug, making the car look like an insect, but the only car donated was a 1974 Gremlin, "one of the ugliest cars ever made!" She spent weeks gathering the beads. This, she claimed, was the easy part because everyone had beads stored in his or her attic. She had so many beads at one point, in fact, that they hung from every knob, handle and lamp in her house. She separated them into piles by color and then glued them with silicone onto the car, following lines of a pattern she had made in pencil.

After several months of gluing beads Jesselyn finished the "Beaded Bug." She said her husband was more relieved than she was because he was so sick of seeing beads all over the place. She drove the car in a parade around New Orleans and

had a great time, but she was afraid to drive it afterward because it attracted so much attention. Other than a few trips here and there, the car remained parked outside under a carport for several years. Unfortunately, Jesselyn learned too late that the sun would fade the color out of the plastic beads. When I filmed the car in 1991, the side of the car exposed to the sun had faded so badly that all of the beads were almost one color: beige. The other side, which had been shaded by the fence, was still in good shape, so that was the side I filmed and later photographed.

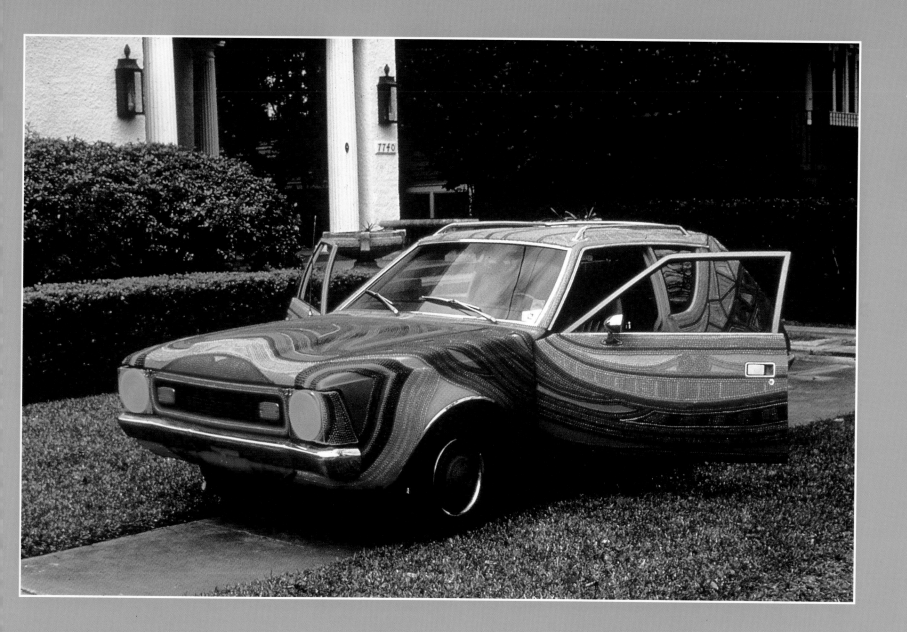

13

BUTTON CAR

Dalton Stevens

One night Dalton Stevens, an insomniac who rarely sleeps more than four hours a night, began sewing buttons on a pair of pants. When he finished the pants he began a jacket, and then he did a shirt, a couple of hats, his shoes, his mailbox, his car, a banjo, a guitar and even a coffin!

What began as a way of passing time developed into an obsession and a way of life.

Dalton was fired from Du Pont,

a chemical plant, for safety reasons. His employers were afraid that because of his insomnia he might nod off while working with volatile chemicals, and they didn't want to take that chance. As a result, Dalton had even more spare time on his hands. After a couple of years of sewing and gluing buttons, he became so popular around town that he earned the name "Button King." He then decided to try to market himself by writing songs about buttons and performing them at shopping malls in cities near his hometown of Bishopville, South Carolina.

As the years went by Dalton became more and more successful, entertaining audiences all over the world. He released a couple of 45s featuring his hit single, "Buttonman Blues," and sold them along with autographed photographs of himself. He was a guest on television talk shows, making three appearances on "The Tonight Show" with Johnny Carson and one on "Late Night with David Letterman." In time his button hobby became a career.

Now Dalton is moving in another direction, the preparation for his death. After attaching buttons to virtually every practical item in his life, he realized that one day they wouldn't be of any use to him—he would be dead. He designed a coffin for his burial and then began working on a hearse, which he plans to have carry him to the cemetery. At the time of this writing, Dalton had

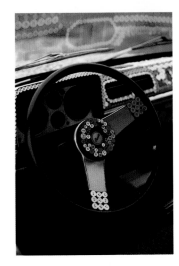

spent four months gluing buttons onto the hearse. He has also made eight button uniforms for the pallbearers. When asked what his last request might be, he said he wanted a bag of buttons, a needle and thread, and a flashlight so he'd have something to do if he woke up!

To order a 45 of Dalton's song "Buttonman Blues," write to: Dalton Stevens the "Button King," Route 4 Box 45, Bishopville, SC 29010.

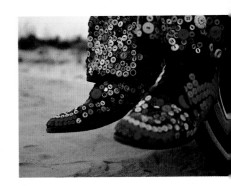

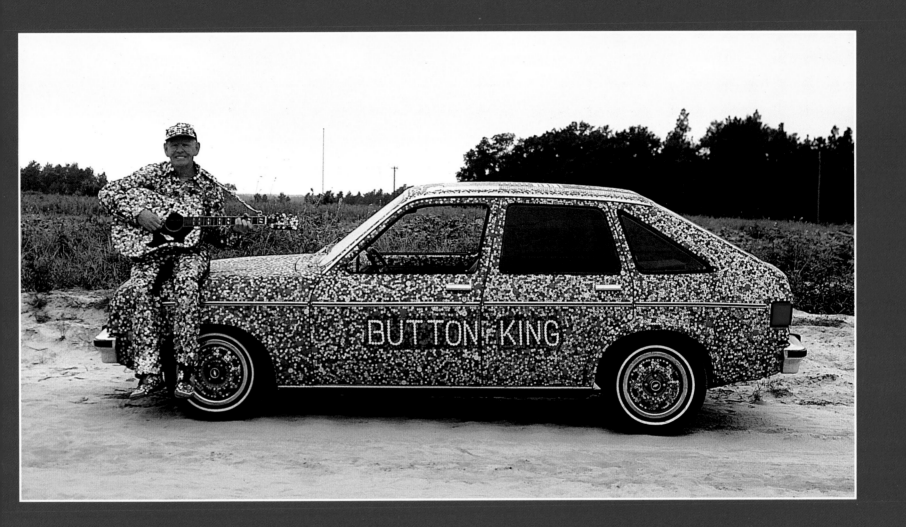

Gary Siebel makes a living as a taxi driver in Seattle, Washington. After years of driving customers around Seattle, he came to know and love all of the city's buildings. He studied architecture in school, and though he never put his knowledge to work commercially, he applied it by making an art car instead.

CITY CAR

Gary Siebel

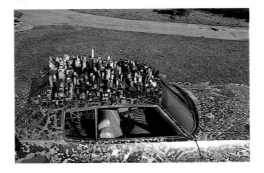

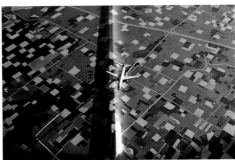

With a pile of wooden blocks at his disposal, Gary began carving and sculpting the blocks into miniature buildings. He glued them strategically in place on the top of his car and even added buildings that were in the process of construction, as in a real city. On the doors, hood and entire body of the car, he spray painted the checkerboard landscape of a city as seen from high above. He added a miniature jet taking off as the car's hood ornament—an effective device for putting the aerial views in perspective.

Gary says that though most people enjoy his car, his biggest problem is vandalism. Hundreds of his buildings have been stolen over the years, and once a person ripped one off and put it under his rear wheel so that he would back over it and crush it. Luckily, he found that building before he got into the car. He says that it upsets him when people vandalize his art

but that he expects it, living in such a large city.

Unfortunately Gary found himself low on money when he went on vacation and was forced to sell the "City Car" to a man in Indiana—for the paltry sum of $500. He is sad that his car is gone but looks forward to making another art car.

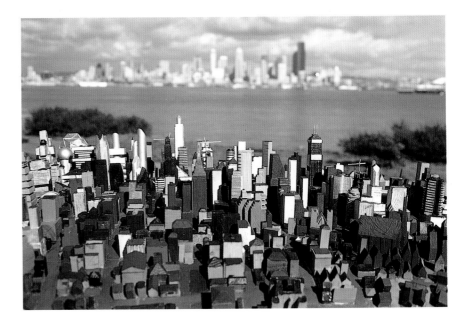

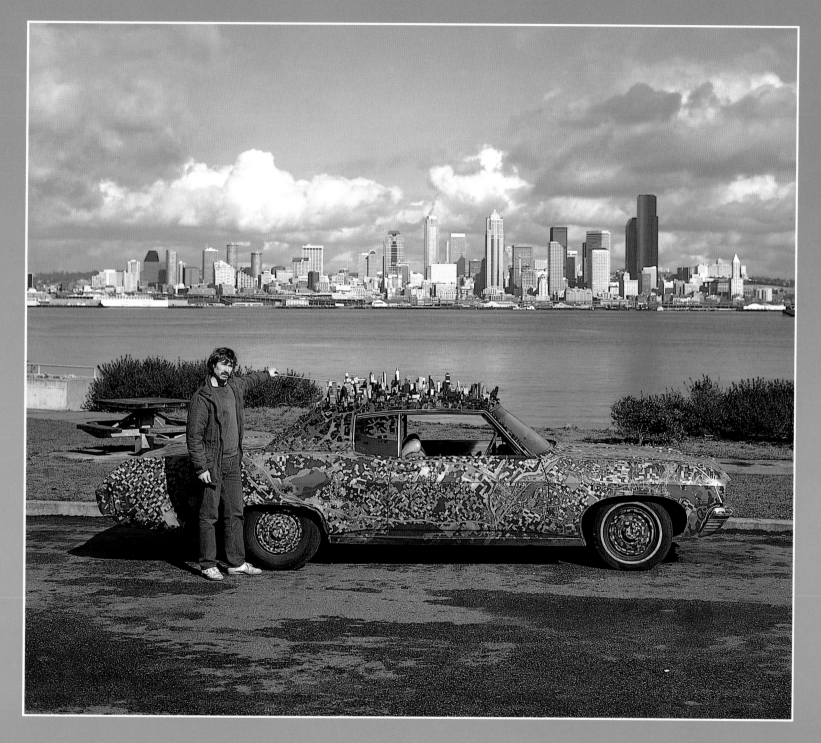

COLTMOBILE

Ron "Colt" Snow

In many cases an art car can change one's life; in Ron Snow's case it saved his life. Ron was an alcoholic and basically was drinking his life away. The problem, which started while he was in the navy, worsened to a point at which he couldn't function at all. His wife left him, he was fired for drinking on the job and he ended up in jail for drunk driving. While in jail he made the decision that he never wanted to drink again.

Ron went to an "A.A." program and at the same time began putting horses on his car in homage to his direct relationship to Samuel Colt, the inventor of the "Colt 45" revolver. He was proud to be the kin of such a famous inventor, and it made him feel better about himself. Every time he wanted to drink, he would glue a horse onto his car.

As the car developed, Ron gained self-confidence. He sold merchandise at the Los Gatos (California) Flea Market and bought all the horses he could find.

After putting 1,400 horses on his car, he had conquered his drinking problem and was becoming quite popular with his "Coltmobile." He even began entertaining people and the media by blowing "horse

calls" on a variety of bugles he had designed. He painted all the horses on his car blue and put "A.A." slogans all over the car to show his gratification. When people ask him

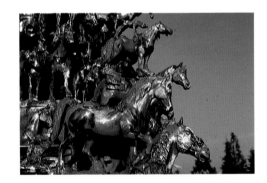

how long it took to make the car, he quips, "It took one day at a time!"

Ron tells about the making of the "Coltmobile" in *Wild Wheels*:

"I can remember several evenings when even at midnight or three o'clock in the morning I'd be outside paintin' on this car with a flashlight and a paintbrush and my glue and gluing these horses on in the middle of the night sometimes.... You know, I got a lot of self-esteem from having this car and having the experience of building it and, uh, actually creating something that I wouldn't have to make any changes in. You know, every horse fit into place as I was putting it together, and it was a very, uh, exciting feeling to be building something like that."

Now Ron lives in Paradise, California, where the "Coltmobile" is stored in a special trailer that he had built. He would like to sell the car to a museum or private collector and hopes that through all the exposure he has been getting, he'll find a buyer. He also hopes that people who learn about the "Coltmobile" and his story of alcoholism will be moved to be creative instead of drinking.

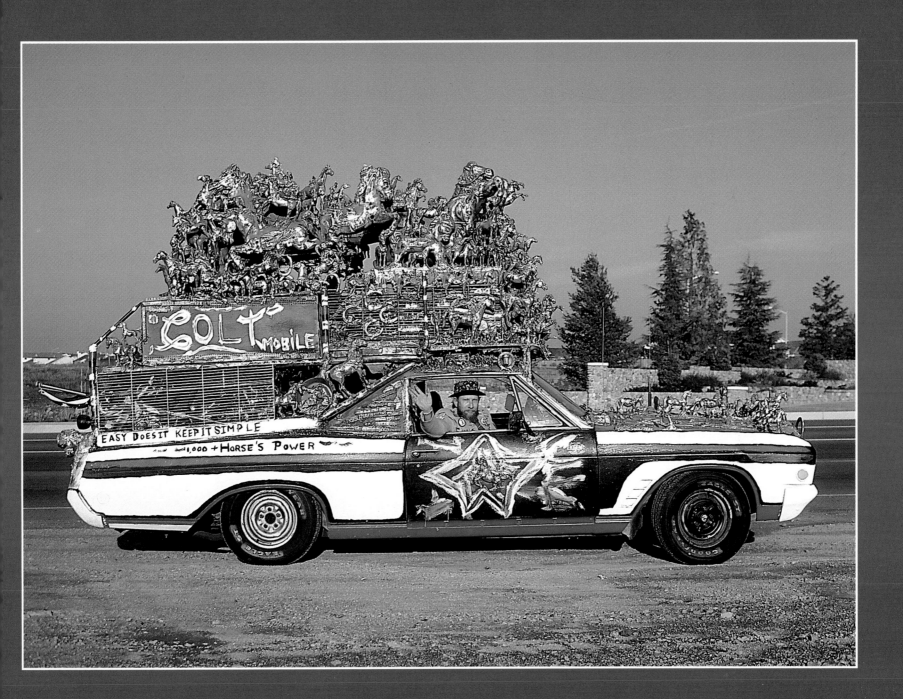

COSMIC RAY DEFLECTION CAR

Chuck Alston

Chuck Alston, also known as "Also Aswell," is the founder and president of the "Cosmic Ray Deflection Society." One of the main edicts of the group is that they must protect themselves against deadly cosmic rays that are increasing all the time because of the decaying ozone layer. The members protect themselves by wearing cosmic ray suits and by driving cosmic ray deflection cars, both of which prevent cosmic rays from penetrating the skin.

It is believed that cosmic rays are semi-intelligent and must be fooled, so the group switches holidays around. They celebrate Christmas on the 4th of July, Halloween on Valentine's Day and so on. Anyone can join the society, but members must be willing to abide by the group's main principle: to have fun and not take American society and its rules too seriously.

When I met Chuck in New Orleans, his "Cosmic Ray Deflection Car" was on its way out and he was depressed about it. We went to an old bar, drank some Jägermeister and talked about the good old times when he was building his car in North Carolina. He told me about how much fun it had been to drive around Greensboro and how he and his friends would smoke pot and spray paint on the car all afternoon. The car was always a part of their fun.

When he realized how big of a part the car had played in his life, Chuck came up with the idea of having a full-on New Orleans-style funeral for the death of his car. He hired a second-line band and gathered together all of his friends and the members of the Cosmic Ray Deflection Society. After a procession through the French Quarter, the car was crushed.

Since the death of his car, Chuck has bought a house in New Orleans and has become a cook at Cafe Degas, a restaurant in the French Quarter. He tells me that as soon as he has a chance, he will create a new "Cosmic Ray Deflection Car." After all, he must protect himself from those deadly cosmic rays!

Larry Fuente is the kind of guy who likes to have fun, and that is basically why he made the "Cowasaki." It is simply a visual pun that gets a lot of laughs whenever he drives it. Some of its features are a horn that makes a loud "moo" sound, a personalized license plate that reads

me on the back. That was enough for me! It shook like a rocket and felt top heavy, as though it might tip over. He just laughed and called me a "chicken shit."

COWASAKI

Larry Fuente

"FUNY COW" and its fueling system: in order to put gas in it, one has to lift up its tail and stick the nozzle in its rear end!

Larry told me that when he drives the "Cowasaki" people stop their cars to look. One time he even saw a car go off the road! Motorcyclists become so interested that they start following him. Police stop him to take pictures and get an autograph, and women flat out beg him for a ride.

Larry says that he has driven the "Cowasaki" 80 miles per hour and that if he pushed it on a smooth highway, he could go over 100 mph! I had a taste of what riding on a speeding cow was like when Larry accelerated over 40 mph with

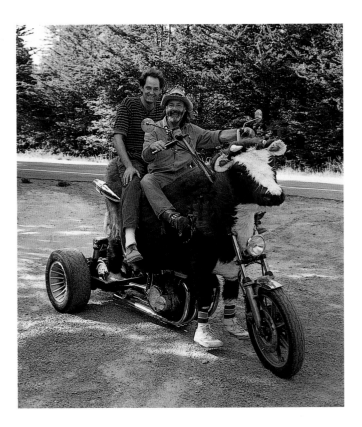

Larry is planning to do a series of motorcycle-powered farm animals, including a horse and a chicken. He is also hoping to take the "Cowasaki" to India, where the cow is considered sacred, just to see what kind of reactions he would get. I am hoping to go with him on that trip to film it!

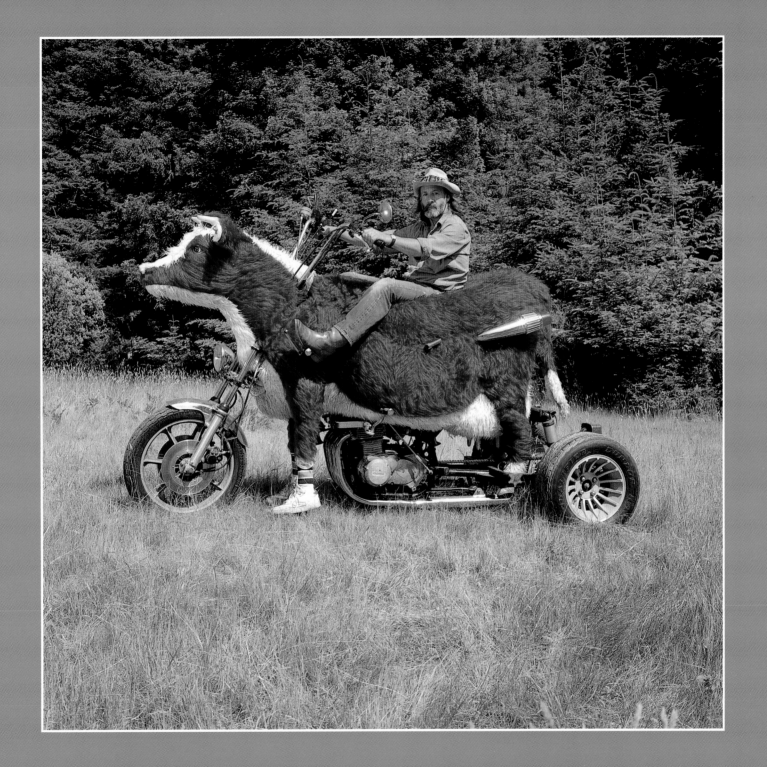

CROSS CAR

W. C. Rice

I visited W. C. Rice in his hometown of Prattville, Alabama, which is fifteen minutes by car outside of the capital city of Montgomery. The film crew and I were driving down a little country highway surrounded by lush, bright greenery when suddenly, after going around a turn, we saw thousands of stark white crosses and religious signs scattered on both sides of the road for a good 100 yards into the distance. It was really eerie for all of us, being from California—like a scene out of *Apocalypse Now*. I had been told that the man who had made the famous "Cross Garden" had a shotgun and fired it at strangers. I found out later that this was just a ludicrous lie.

W. C. Rice has been putting crosses and crucifixes on his land, in his house and on his "Cross Car" for over twenty years. His family is very accepting of his hobby and actually encourages him to continue it. His "Cross Garden" attracts many interesting visitors and also brings business to the trailer park that his wife manages behind their house.

W. C. told me that many people don't understand why he does what he does, that he is persecuted and ridiculed by many. He believes that it is good, though, to be persecuted because it means that he is different and an individual. He believes that the society we live in is inherently evil, full of the wrong kind of sex, sin and violence. W. C. paints slogans about the evils of society on throwaway items like refrigerator doors, old gas and electric dryers and discarded Coke machines. He puts white crosses and crucifixes all over the place. He works on his "Cross Garden" and drives around in his "Cross Car" as a testimony to his faith and uses his creations to attract people to listen to his preachings.

While some people may be turned off by the religious fanaticism of W. C.'s work, it didn't bother me at all. Rather, it made me curious. Even though I do not adhere to any one religious belief, I can relate to the aspect that he has created his own place, his own "environment."

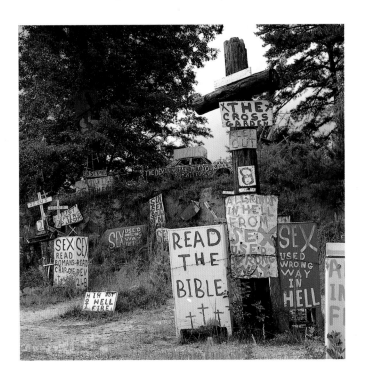

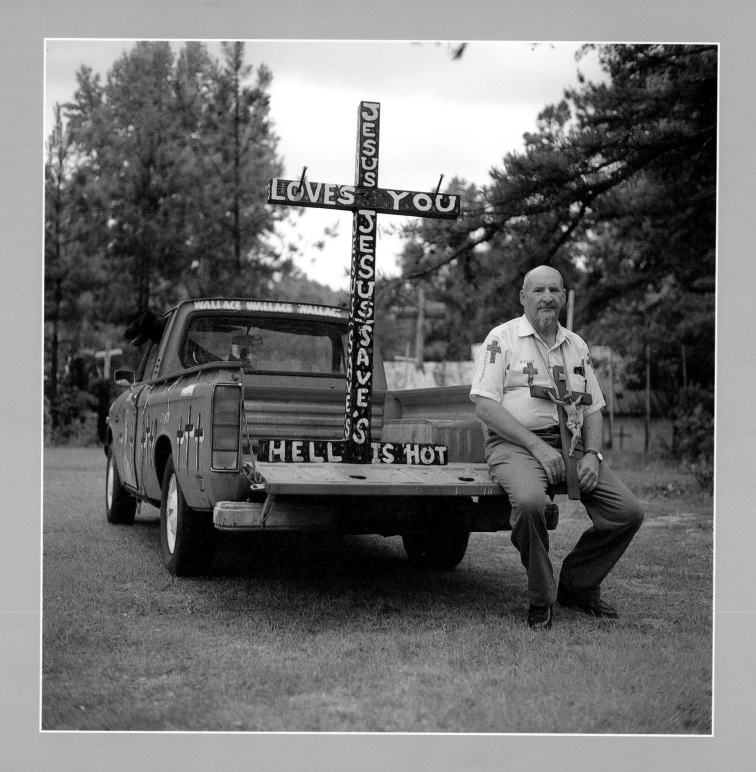

DADDY'S CADDY

Junior

At age nineteen Junior (born Anthony Mendes) left his home in Salmouth, Massachusetts, to look for work on nearby Martha's Vineyard. His specialty was drywall construction, and at that time many houses were being built on the island. After only a few days on Martha's Vineyard Junior met a beautiful woman named Flora, a native of the island, and the two fell madly in love. After three weeks they decided to get married.

Junior had had a drinking problem since he was about thirteen,

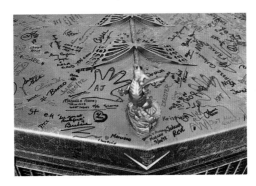

and after his marriage he began drinking even more to escape the fact that he and his wife weren't getting along. He realizes now that he had married too soon.

In 1985 Junior conquered his problems with alcohol. Ironically, it was then that his marriage really began to go downhill. He and his wife separated and eventually divorced. Unable to bear seeing his ex-wife around on the tiny island, Junior fled to San Diego. He couldn't find work there and ended up sleeping in a cemetery and surviving by selling his plasma. After five years, he finally pulled himself together and returned to the island.

Shortly after his return Junior began spray painting his Cadillac with gold spray paint to try to spruce it up a bit. His friends mocked him, and one of them jokingly asked if he could sign the golden Caddy. Soon everyone on the island wanted to sign it, to be a part of it. At first he allowed only local islanders to sign it, but eventually he opened it up to the thousands of tourists who flock to the island. After over 60,000 people had signed it, including James Taylor, Carly Simon, Larry Bird and Spike Lee, Junior repainted the car to make room for more names. He estimates that he has over 30,000 signatures on the car now.

Junior told me that the car was just what he needed to forget his sor-

row over his ex-wife, whom he still loves. It opened him up completely and has given him self-confidence that he never had before.

Junior has a few gimmicks he uses to entertain the crowds. In the backseat is a tank that shoots a stream of water out of the roof, ten feet up in the air and into a porcelain fountain mounted on the trunk, on which sit several fake birds. He also likes to take a drag on a cigarette inside the car and blow the smoke into one of three plastic tubes. One tube is routed to a dragon hood ornament and the other two blow

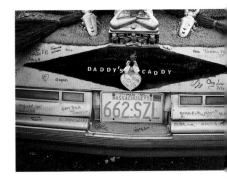

smoke out of a pair of motorcycle mufflers mounted on either side of the car's rear.

In addition to the writing on his car, Junior sports tattoos on his own body. Written on his forearm is the legend *Young, Gifted, and Black*, and across his chest are the words *I love Flora*.

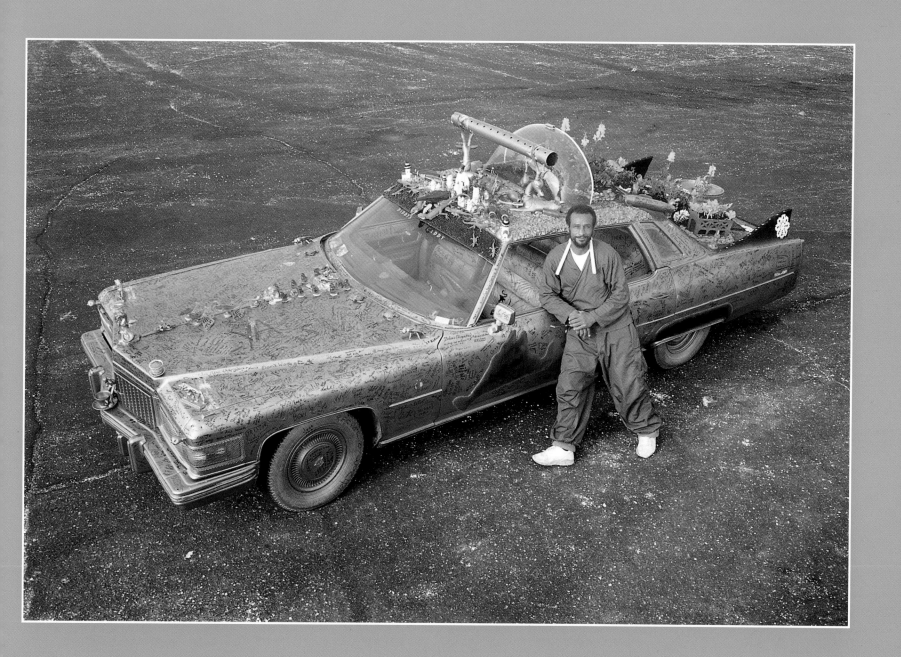

Over the years David Best has directed the creation of fourteen "decorated cars," which he describes as vehicles on which he encourages the general public to express their pains and joys. He has been invited to create a "decorated car" by the Aria Nightclub in

DC-6 & DC-13

David Best and the Public

New York; the Orange Show Foundation in Houston, Texas; the Los Angeles Temporary Contemporary Museum; Chico State and Sonoma State Universities; the San Francisco Exploratorium and the Sonoma County dump. The process sounds simple but can be complicated and intense in real life.

"DC-13" (Decorated Car #13) was sponsored by the Houston Orange Show Foundation, which provided the car and boxes of supplies, mostly plastic knickknacks and other throwaway items. David Best arrived by airplane and began work immediately by assessing the car—his canvas—and the pile of supplies.

David usually prepares the car with a few friends by doing some preliminary welding or cutting of the car. In making the "DC-6" in collaboration with Michael Bishop, he welded a second door to the rear doors so that when they were left open the car looked like an airplane ready for takeoff. He also welded a second set of chrome bumpers in front of the existing bumpers, which created an unusual look. Then with the addition of the hood ornament, an authentic stuffed rhino head, the car was ready for the next stage.

The next step is to invite the general public to glue things on with silicone. David oversees this process, teaching the people how to

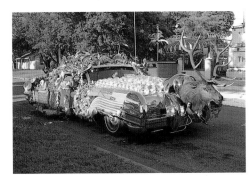

DC-13

glue, what to glue and in some cases where to glue. Children love it because they rarely have the opportunity to create and stick

David Best

things on something as precious as an automobile. The children's parents love it because their kids are entertained for free. The car is usually completed within a week.

In addition to involving the community in the creation of the car, David also enjoys the process of recycling, of taking discarded plastic items and giving them a second life—a life of artistic meaning. His "decorated car" experiences have all been entirely different from one another and positive, not just for himself, but for the various communities involved as well.

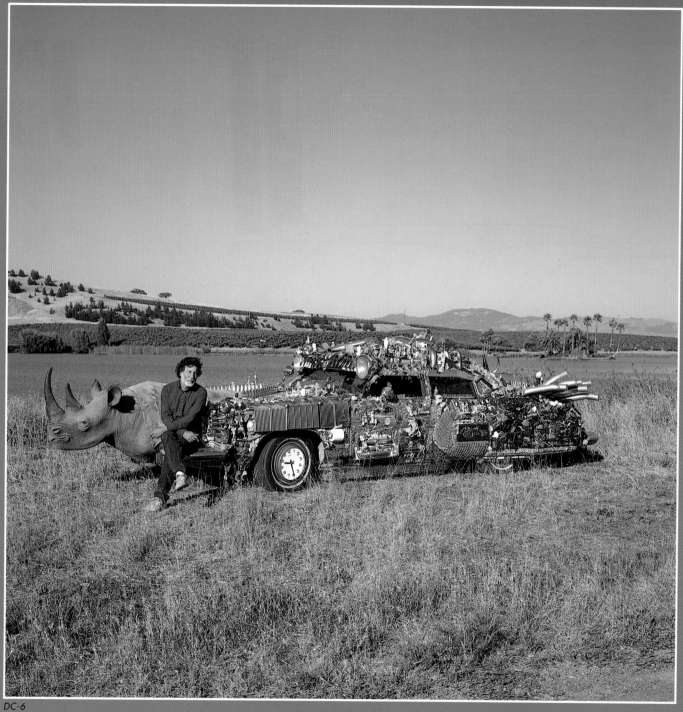

DC-6

FAUCET CAR

Bob Daniels

A lot of people ask me how I came into contact with all of these art cars. The most common way is by word of mouth. The most classic example of this happened in Montgomery, Alabama, in July 1990.

I was working as a set dresser on *The Long Walk Home*, a film starring Whoopi Goldberg and Sissy Spacek, and I had brought my car "Oh My God!" One day after work I had a headache and I drove to a "Stop 'n Go" store to get some aspirin. A woman coming out of the store saw my car approaching and reacted with disgust. I got out of the car and was walking toward her when she began shaking her head. "Man-n-n, your car is UG-G-GLY!" she said, as I passed by.

I turned back to her defensively. "What do you mean? It's a work of art! You know, I happen to be making a movie about cars like that!"

"Oh, really? Well, I know a car that's even uglier than yours! It's got water faucets all over it!"

I found this news exciting, of course, and found out that the "Faucet Car" was in Andalusia, Alabama. I called the Chamber of Commerce there the next day, and they were familiar with the car. They gave me Bob Daniels's name and number, and a couple of weeks later I went to visit him. I never would have found out about him if I hadn't driven my car to Alabama.

When I finally met Bob, he told me his amazing story. One night while he was in a mental institution in Philadelphia, he had heard a voice but no one else was around. He assumed it was the voice of God. The voice told him to put faucets on his car and to be clean. Shortly thereafter, his life changed. He was given a big Social Security disability check and released from the mental institution, at which point he bought a car and drove to Alabama. There he rented a mobile home and immediately began putting faucets on his car.

Bob became one of the most popular people in town and used the "Faucet Car" as his "fishin' transportation." He and a bunch of his buddies would go fishing almost every day. He claims that ever since the afternoon he heard God's voice his life has been great.

Although everyone in Andalusia knew of the "Faucet Car," not everyone liked it. I asked him how he felt when people said it was ugly. He responded, "Yeah, there's people who don't like it, but, hey, that's on them. There's a lot of people who do like it. I'm proud of what I did for the simple reason, hey, I got somethin' nobody else don't have!".

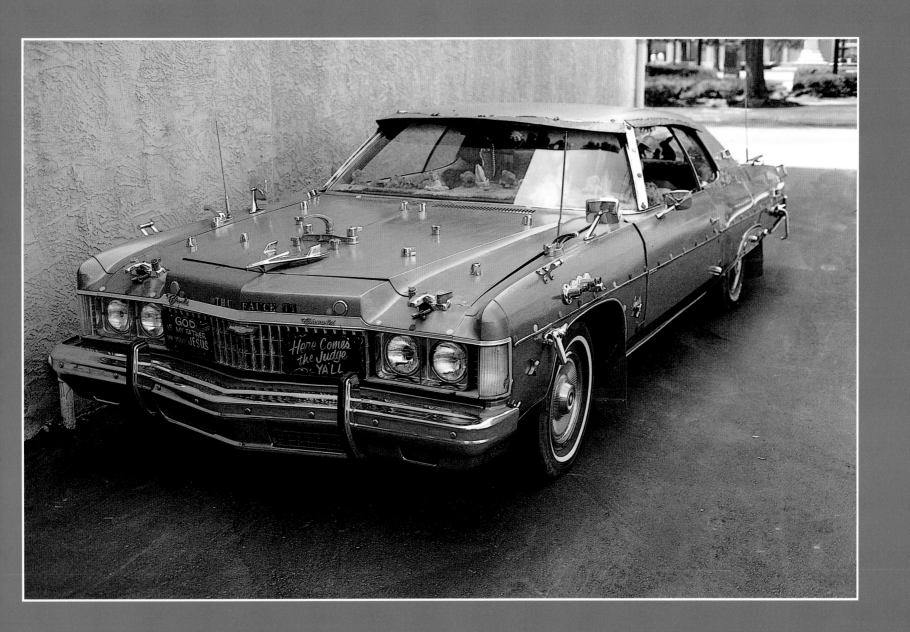

5:04 P.M.

Michael Mikel

After the earthquake hit San Francisco at 5:04 P.M. on October 17th, 1989, Michael Mikel was walking around looking at the damage. He came across a car that was buried under a brick wall, and instantly he hit on an idea. Wouldn't it be a great statement to drive around in a historical monument? He located the owner and asked him if he would be interested in selling his car. "Go ahead, take it. It's ruined," the man told him.

After getting a new windshield, some minor repairs and a new paint job, the car was ready to roll. With the addition of a license plate reading "5 04 PM," the car was a fitting monument to the forces of nature. Michael still drives it today as a testament to the survivors of that historic moment. He also likes the fact that his big, ridiculously crushed American car mocks the automobile industry's image of polished perfection.

The "5:04 P.M." fits right in with Michael Mikel's life, as he is always coming up with large-scale pranks and unique ways of having fun. He is an active member of the Cacophony Society, which is a group of eccentric individuals who gather in the "pursuit of experiences beyond the pale of mainstream society." One of their many zany pranks was to sneak the car onto the closed Embarcadero Freeway exactly one year after the quake. The "5:04 P.M." became the very last private automobile to drive on the now demolished freeway.

Other events in which Michael has participated as a Cacophony member include a huge tea party on the Golden Gate bridge, a formal dress tour of the Oakland sewer system, the burning of a fifty-foot-tall wooden man in the Nevada desert and wild nostalgic parties in abandoned army bunkers in which all guests dress according to a certain era or theme.

If you would like to learn more about the Cacophony Society's bizarre activities, write to P.O. Box 426392, San Francisco, CA 94142.

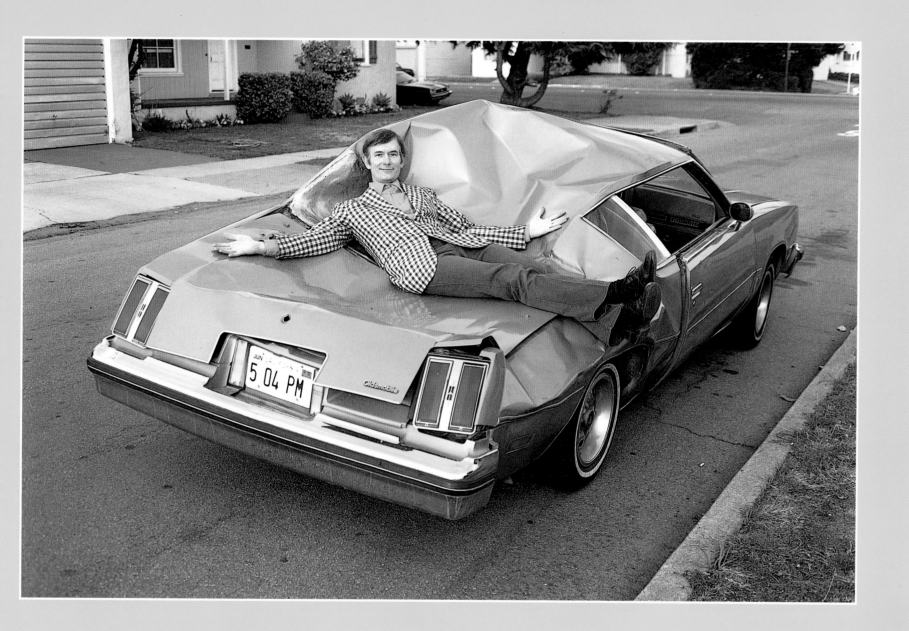

Jackie Harris, a prolific artist in Houston, Texas, has created ten art cars. The "Fruitmobile," her third, was commissioned by the Houston Orange Show Foundation, which is a folk art museum and cosponsor of the notorious car art event Roadside Attractions: The Artists Parade.

FRUITMOBILE

Jackie Harris

Jackie created the "Fruitmobile" in 1986 as a "moving still life." Using acrylics, she painted a variety of fruit, flowers and fish onto a 1979 Ford station wagon. She then added a

third dimension by attaching plastic fruit and flowers within her paintings, and painted over the plastic objects with acrylics so that they would fit into the style of the whole car.

The "Fruitmobile" glistens in the light and the paint appears fresh because Jackie sprayed the car with several coats of Delclear, an acrylic coating that protects paint from fading and peeling. She says that most of the paint is original and that the Delclear will protect it for at least ten years. Most of the maintenance consists of replacing pieces of fruit that have been blown off in the wind or accidentally broken off by the daily fondling of passionate art enthusiasts.

Jackie is a topless dancer and says she makes "a damn good living." She likes stripping because it attracts to her people who accept her for who she is. I asked her if there was any correlation between her job and her art:

"Being a stripper and driving an art car are very similar—they are both a performance. When I drive the 'Fruitmobile,' whether I want to or not, I am performing. People stare, they come up and ask questions, and I entertain them."

When I found Jackie's house I didn't need a street address because just above the front door was spray painted in foot-long black letters, "Jackie's House of Weapons—Always Open!" Inside I

had quite an experience when I had to go to the bathroom. On the bathroom door at eye level read "Blood Bath" painted in red spray

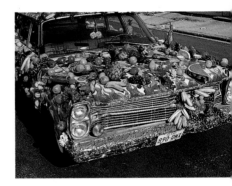

paint that had dripped. Red, drippy handprints were scattered about the face of the door, and a pool of red paint reached out two feet from the doorjamb. When I opened the door there were more red spray-painted handprints and a decapitated papier-mâché head affixed to the floor facing the toilet some two feet away. It was the most unforgettable bathroom I have ever been in!

When I returned to the living room Jackie came rolling out of her bedroom wearing a neon pink tutu and roller skates. She was getting ready to go skating in downtown Houston with her girlfriends. She is one wild woman.

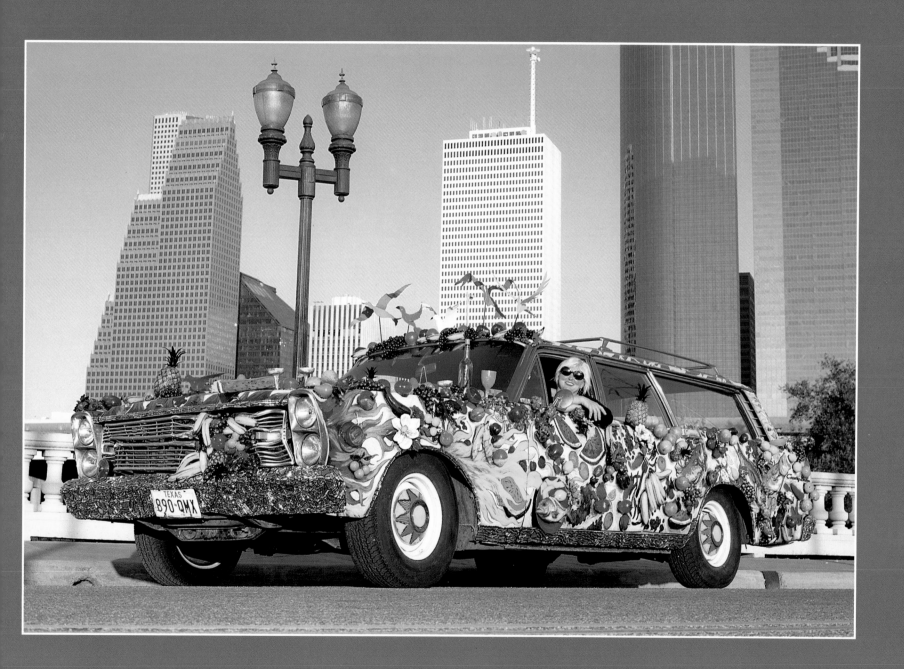

GATOR CAR

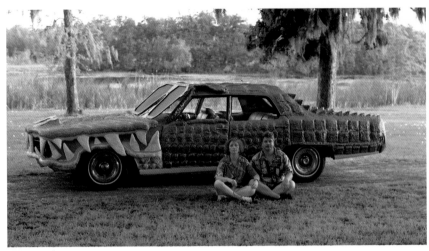

Moira and Tom LaFaver

John Wells and Tom & Moira LaFaver

John Wells's mother, Olga, had a 1970 Buick Electra parked in front of her house for over three years. When the police threatened to tow it away, she asked John to do something about it. He called his friends Tom and Moira LaFaver, and the three decided to make an art car out of the Electra and enter it in the upcoming (April 1989) Roadside Attractions parade in Houston.

The project, which they originally thought would take about twenty hours to complete, took close to four months (they barely finished in time for the parade). The first obstacle was getting the car started. It turned out that there was a rats' nest inside the carburetor! After blowing out the nest with an air hose, the car miraculously ran fine.

The "Gator Car" is made of papier-mâché and paint, covered with a layer of Delclear acrylic. It has a 455 cubic inch engine, and John claims it can go over 100 mph. He races it in local auto races.

The "Gator Car" has been in every Roadside Attractions parade since 1989. Each year Olga rides in the passenger's seat and entertains the crowd with her festive and flamboyant wave.

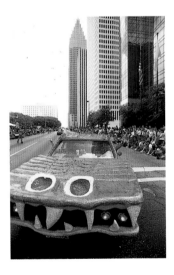

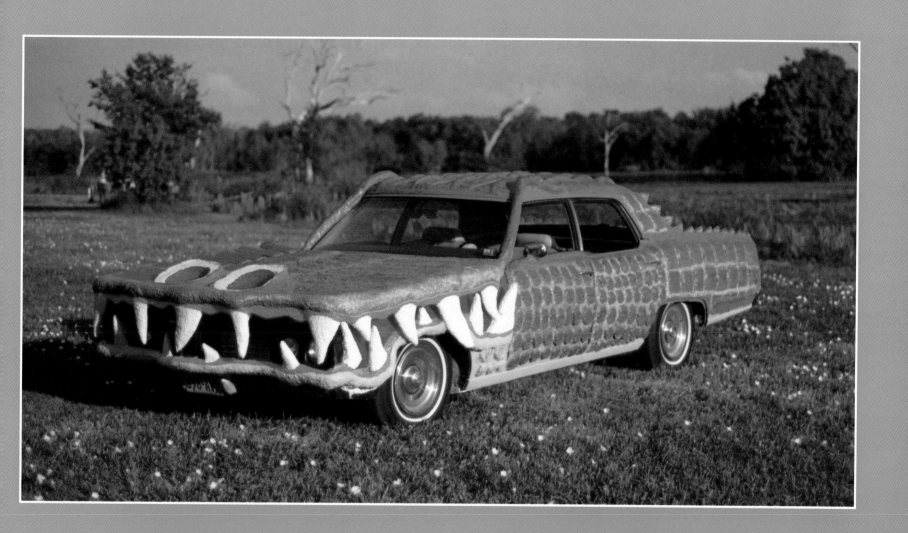

In 1987 Charles Hunt knew a woman who was selling a tan 1964 Comet. He offered her $500 for it, but she wanted to see if she could get more. The woman's father tried to help her by painting it bright purple, but he did a lousy job, dripping paint all over the windows and

THE GRAPE

Charles Hunt

the chrome. As a result no one would buy it for any price—except for Charles. Even though he hated the color purple, he wanted a funky car to drive to work in. His friends

thought the car looked ridiculous and nicknamed it "The Grape."

Charles decided that because "The Grape" was such an ugly car, he couldn't make it worse.

Like many people who create an art car, he had never seen one before and learned as he went. He cut the roof off, painted the whole car with primer and began adding things. Because he didn't have a stereo, he added bells—lots of them, so that every time he hit the littlest bump the whole car would jingle. He added bones as a reminder that he could die at any moment and that life was precious. He stuck on his favorite stickers and painted on slogans he had become attached to. One of his favorite discoveries was the effect of cutting holes into the doors to make extra space in which to put things.

Charles recalls that when he was nine years old he told his father that when he grew up he wanted a car that was different, with swirly swirls and wild colors, like a Dr. Seuss car. He says that "The Grape" is the car he's always wanted.

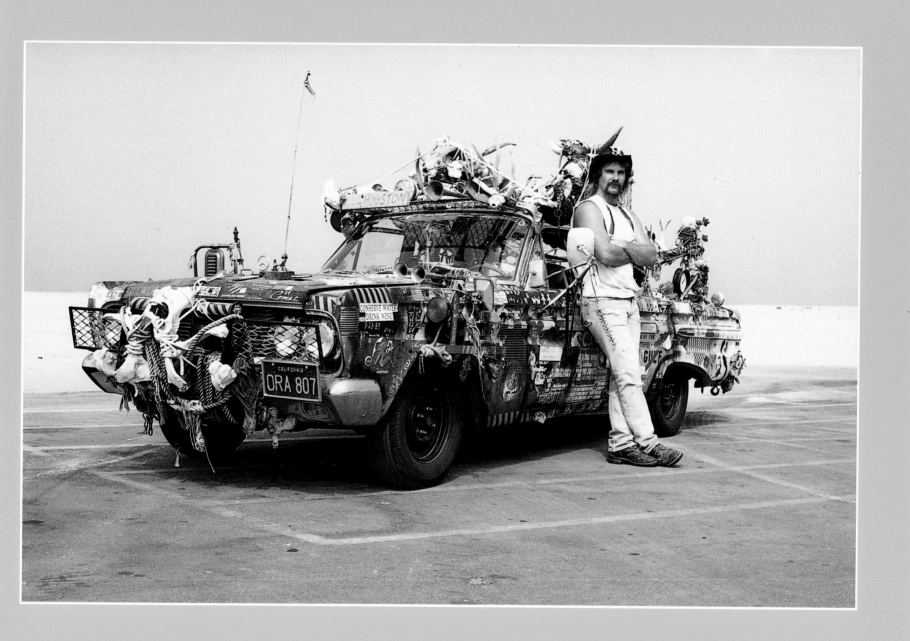

In June 1981 Gene Pool gave a performance at the Farmers Market in Kansas City, during which he wore a grass suit that he had grown from seed and he was chased around by a man with a lawnmower. The event went over extremely well and encouraged him

GRASS CAR
& CAR POOL

Gene Pool

to experiment making other grass-covered objects.

In *Wild Wheels* he describes making the "Grass Car":

"I spray the car with petroleum-based industrial adhesive, and I'm working with different kinds of adhesives now to find a better method. I cover certain areas of the car with adhesive, then I spread the seeds on there. Then I start watering, and in the process a lot of the seeds fall off in different places and I have to patch it. Then . . . I usually cover

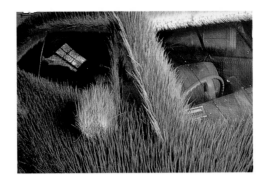

it up with just a big sheet of plastic for a couple days 'til it sprouts, and then I build a system of frames that hang over the car on ropes. . . . This holds the plastic over the top of the car and there's like—it's always wet around the car so there's a water seal that holds all the moisture in. And that whole day I spend the time with the car building these frames and I watch, I virtually watch the car grow.

"In the morning the blades are about an eighth of an inch long and white; by the end of the day they are three-quarters of an

inch long and . . . green. When I go out in the garage in the morning, there would be a tiny drop of dew, a little drop of water, on every single blade, and you'd open this up and just this forest, just this beautiful forest like, almost like a city. And it's like a portable environment.

"And there's a whole process that the car goes through from the time it sprouts and until it dies, and I kind of adhere to this. I have to water it every day and have to care for it, and, uh, I just develop this real love for it, for its effect on people and for the whole, whole concept of the car."

When Gene grew his first "Grass Car," he enjoyed the irony of making something that was alive, growing and beautiful on top of an ugly old automobile that made a loud, awful noise and polluted the air. He didn't realize at the time that the popularity of the "Grass Car" would catapult him into worldwide media stardom.

In 1982 Gene was interviewed in newspapers and magazines, on local television news programs and on "The Tonight Show" with Johnny Carson. The national publicity had his phone ringing off the hook, and for the following year he was

hunted by the media. After making several "Grass Cars" to display at art galleries, museums and schools, he decided to call it quits. He felt that he had been reduced to a

"Grass Car Man," and he wanted to do other things in his life.

Gene began doing other performance art pieces, including another art car called "Car Pool," a drivable station wagon full of water and living goldfish! He also began to pursue an interest in music and formed a band called "Hand to Mouth."

Around the same time he was still interested in working with grass, although he wanted to scale down the experience of the sensational "Grass Car" to a more personal level. He directed an event in which thirty-seven people wore "Grass Suits" and walked around downtown Chicago for a day. He also appeared in David Byrne's film *True Stories* wearing a grass suit.

Gene created more wearable art by designing the "Money Suit," a suit completely covered with pennies and dimes, with a dollar bill tie and an interior lining composed of bounced checks. As a performance he went downtown wearing the suit and begged for money one day, then gave it away the next.

Gene Pool moved to New York in 1989 and has since created a "Can Suit," a suit made out of aluminum cans, and a "Drum Cycle," a bicycle that plays the drums when one rides it. He also sang everything he wanted to say for an entire week. I recently asked him if he would make another "Grass Car" to help promote *Wild Wheels,* and he said only if he could grow the grass on an electric car!

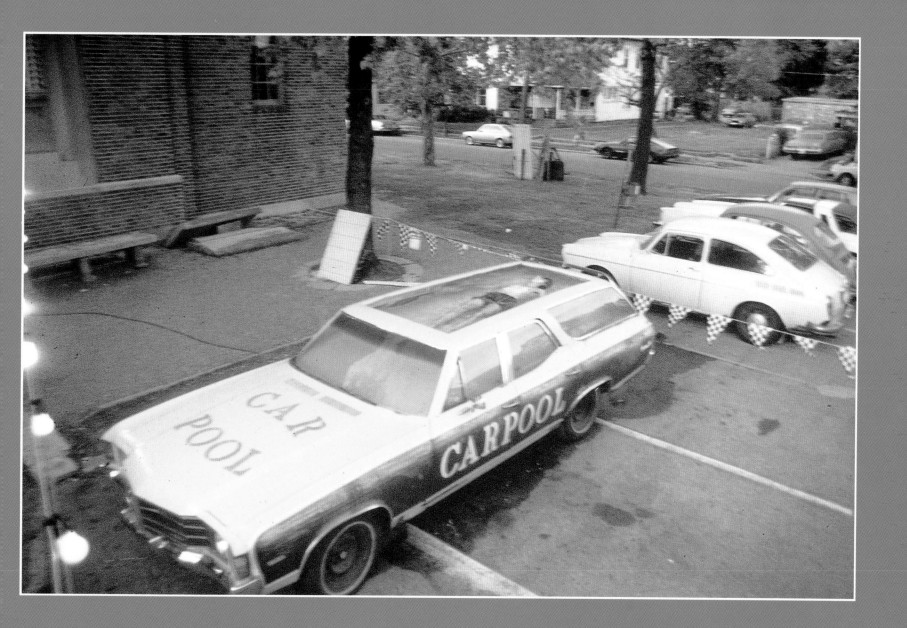

An art car attracts so much attention that it can become more of a nuisance than it is worth. Albert Guibarra, a prominent sculptor and the creator of the amazing "Hippomobile" testified to this fact when I asked him to appear in *Wild Wheels*. He refused, saying that he

HIPPOMOBILE

Albert Guibarra

wanted nothing to do with the "Hippomobile," that he was sick of the attention and of being associated with it. I begged him over the

course of several months to just say that on film, stressing that he was making a valid point, but again he refused. After a year passed, I called him again. This time he told me that he had sold the car to Don

Tognotti, a man involved in custom car shows, and that if I wanted to film it I should talk to him.

Don Tognotti granted me permission to film the car with its designated driver, Mike Andreeha. Underneath the 600-pound brass and copper hippo is a 1971 Ford Mustang convertible. The car features a built-in PA system connected to a tape deck stereo. At the flick of a switch it plays a variety of hippopotamus tunes including "I want a Hippopotamus for Christmas." It also makes the groaning sound of mating hippopotami, which resembles that of the starter of an old truck being turned over and over.

The car has a wagging tail and is nicknamed "Puddles" because by the push of a button it squirts water from a hole under its tail, leaving large puddles if it is stationary and a thin trail if it is moving.

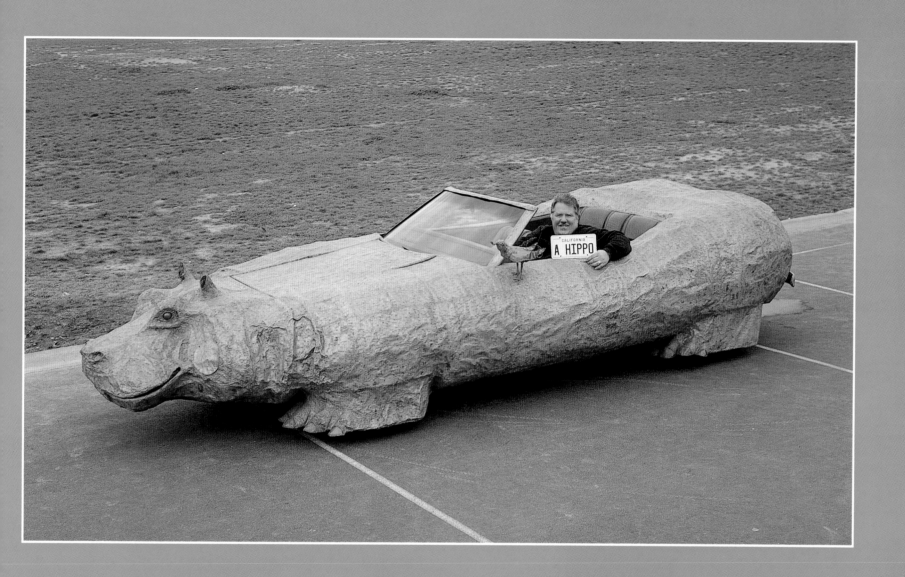

Many people who create art cars are not aware of why they are doing it. They just kind of get started and then keep going. In 1984 Peter Taylor spray painted his 1964 Ford Econoline van with black spray paint. After one of his friends told him that it looked like a

HODGEPODGE

mausoleum, Peter vowed to change that image. He attached a sculpture of two cherubs and a family crest and gradually added items until it was completely covered. When asked why he did it, he responds, "I don't know, really. One thing just led to another!"

When he ran out of room Peter began adding a second layer of objects. What is unique about his

style are the sculptures covered with beads and the pictures framed by brightly colored beads. There are also a number of statues, stickers, buttons and signs that involve the word love. When asked why he continued working on the van Peter responded, "Well, once I got started, I had to keep it up. Things fall off or people pull them off and I have to keep it looking nice."

He finds most of his items at thrift stores, garage sales and flea markets, and many people give him things as well. He frequents the local beaches in La Jolla, California, where he lives, and enjoys meeting the people that his van attracts. It encourages conversation and provides a good escape

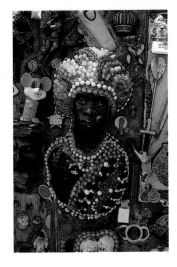

from his work, which is in cement construction.

Peter says that he has not made anything else creative besides "Hodgepodge" and that the closest he came to art training was when he was a model for art classes!

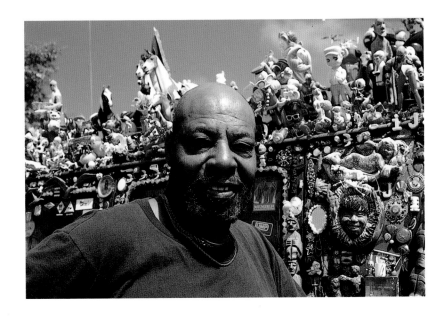

46

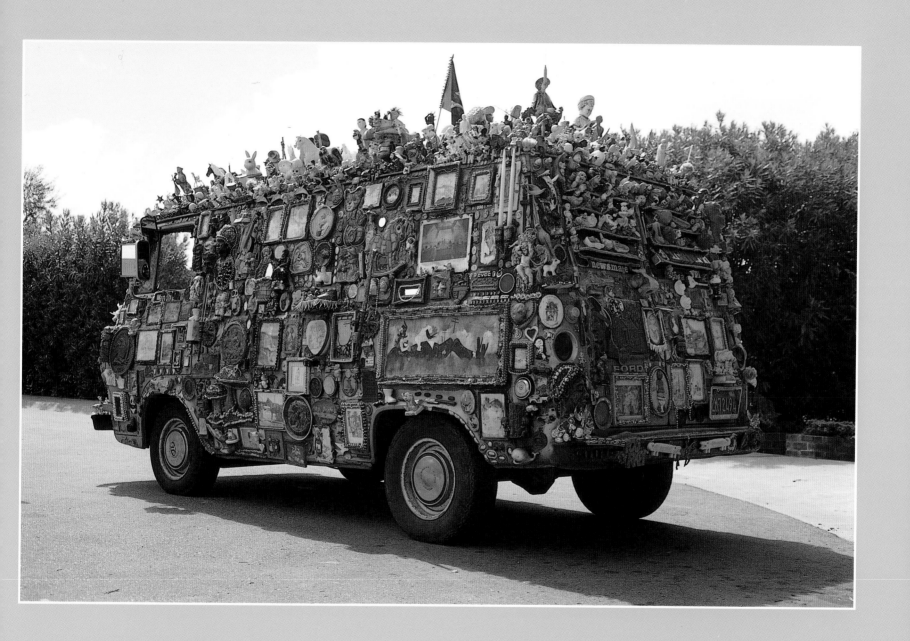

HOOPMOBILE

Hoop

I had heard about Hoop in 1990 when I was in New York filming the "Lightmobile," but I didn't have the money to buy more film. Three years later *Wild Wheels* played at The Film Forum in New York and I called Hoop to see if he wanted to help promote the opening. He agreed enthusiastically. I brought my camera along and took some pictures of him in downtown Manhattan.

Hoop, who resides in Clifton, New Jersey, has made ten art cars, all of which feature his name in big letters on the doors. He said he was often frustrated when pictures of his cars were published in magazines and newspapers without giving him credit—now no one can miss his name!

As Hoop explains:

"Since I was a kid I have always been interested in unusual vehicles. When I started driving I always chose odd makes and models like the Henry J, the Nash and little-known foreign cars. The first vehicle I covered with material was in the mid '70s. I had a 1970 Siata Spring that I wrapped in black leatherette. After a few more vinyl vehicles, I switched to something with more texture—fun fur!

"I selected my VW-powered 1958 BMW Isetta for the next project. Covered with a beautiful coat of purple fur, it looked like a motorized grape. By this time it was the mid '80s and New York's hot art scene was in the East Village. Being an artist myself, one day I was gallery hopping and I met a woman who was putting together a 'Cars as Art' show for a 4th of July party at a club called 8 B.C. I agreed to participate. I went home and ripped off the purple fuzz, replaced it with white and proceeded to airbrush it with a rainbow of fluorescent colors. The response I received at the party and on the street afterward was fantastic. As I drove through all different areas of the city and the suburbs I got the same reactions—smiles, laughter and surprise.

"I've continued to create new 'Hoopmobiles' so I can keep those smiles coming. As an added reward it's helped increase my recognition in the art world with lots of press, museum shows and the opportunity to meet thousands of wonderful people.

"Some of the other cars I've refurbished are a 1961 Trojan 'Bubblecar,' a 1977 AMC Pacer 'UFO,' a 1941 Packard funeral limousine, a 1968 Fiat 850 winged wonder plus various vans and Volkswagens. I am presently looking for a 1960s-style Vespa three-wheel hot dog wagon."

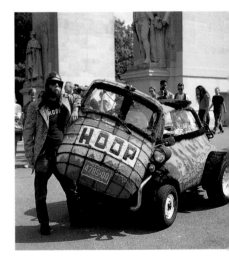

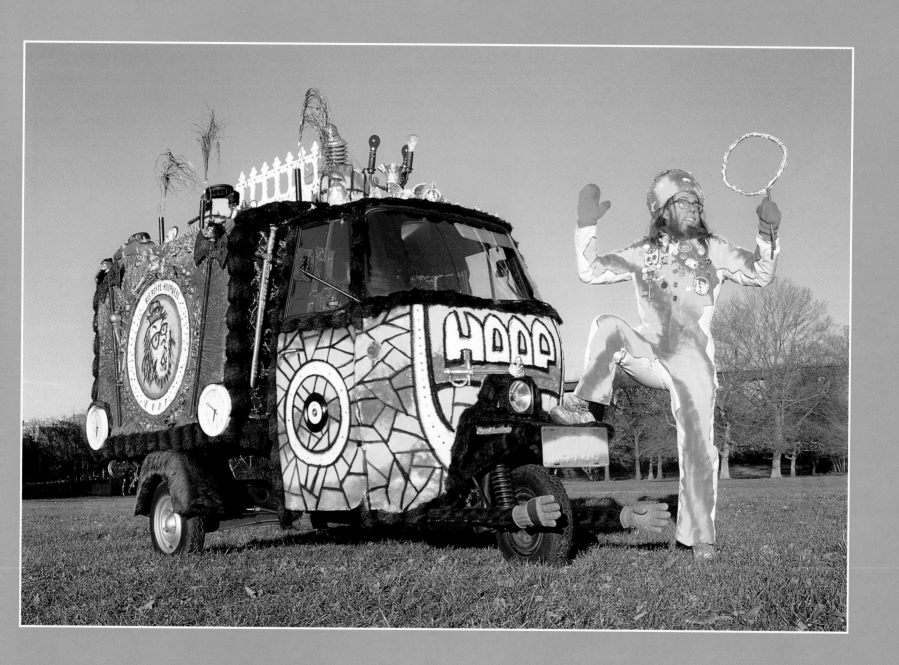

JESUS TRUCK

L. H. Gandy

When L. H. Gandy was a boy he idolized James Dean. He would drive for hours to see Dean's films because in his hometown of Coolidge, Georgia, there was no movie theater. He dressed like James Dean, memorized all of his lines and especially related to his desire to be loved. Then his hero died in a car wreck. As Gandy told me, part of him died on that day also. He went through a period of severe depression and heavy eating and gained a lot of weight in a short period. At the same time, he began reading the Bible, carrying it with him wherever he went. He began memorizing complete passages, writing down his favorite lines and also sketching biblical images. He had always had a talent for drawing, so he decided to go to art school. From then on he painted obsessively. It was the only thing that really made him happy.

When I met Gandy, I was very taken by his truck, with all of its humor and strong paintings. I was even more taken when he showed me his studio. All of the exterior walls were covered with huge religious murals, and on the inside every inch was covered with paintings of James Dean. We were in his studio when he told me he had been diagnosed with schizophrenia. Then it made sense to me why sometimes he would preach about the Bible and then a second later hail the greatness of James Dean.

I had never met a schizophrenic before, but Gandy didn't seem handicapped or weird or anything. Rather, he was really intriguing and a gentle person. He pulled out a guitar, which seemed like a toy against his massive body, and sang extremely powerful love ballads. He told me that he wanted to be loved, but many people judged him by his overweight appearance. In his early forties, he lives with his mother and his dog.

One of the unique things about Gandy is that he constantly repaints his truck. Virtually every week he paints over great paintings with more great paintings. I could not understand how he could do that, but he stressed that it was the "process" that was important. He sometimes sells his paintings to get by, but if you show that you really appreciate his work, he'll paint it for free.

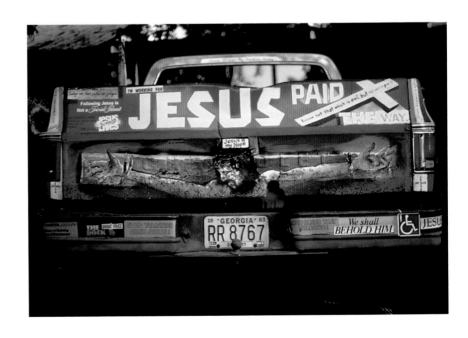

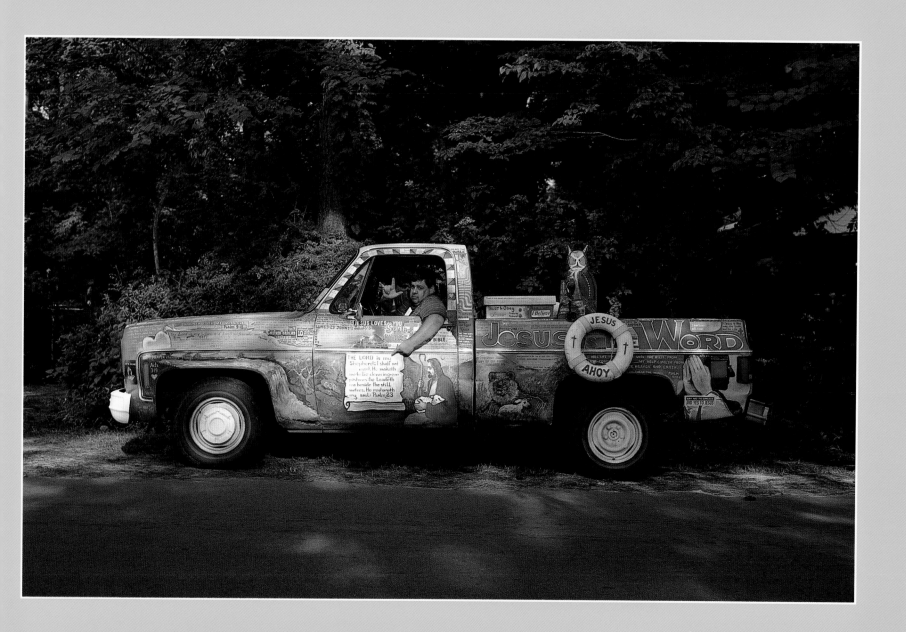

JEWEL BOX

Jay Battenfield

Jay Battenfield, mourning the death of his wife, began attaching his wife's jewels to his 1960 Corvair. This began a process that he said was very therapeutic for him. He tells about the tragedy and his "Jewel Box" in *Wild Wheels*:

"My wife was killed in an automobile accident.... Uh, there was a truck in the lane next to her and she ended up under the eighteen-wheeler. He drug her about a mile, close to a mile, and, uh, she was killed instantly.... The car has brought me some contentment and helped me to dispel the anger that I had built inside at the loss of my wife. This car is in her memory. Every item on it has a mean-

ing. It has black diamonds, pearls, amethysts, rubies, jade. And the most a person can hope for is a friend as Jean, my wife, was. She was born in Blackpool, England. She was what you would call a 'throwaway child,' and she grew up in an orphan's home. She was a starlet in movies at Sheperdson Studios, she was a singer, uh, she spoke seven different languages, she was a good artist, she was a registered nurse, and she accomplished all these things in forty-some-odd years. She lived longer and did more things than most people will in a hundred and fifty years! She said she'd never be ill and she'd never be old, and that's the way it turned out.... The bracelet, that was her opal gold bracelet. The opal rings and the opal locket are perfects. They are very unique, just like she was. You have another item there that she wore that she liked very much— that was a blue starfire ring. And, uh, you have many bracelets and gold chains, and uh, items that are unique within themselves...."

Jay keeps the car stored in an alarm-secured semi truck and says that though the car is worth millions, it is not for sale. One man offered him $300,000 cash, but he

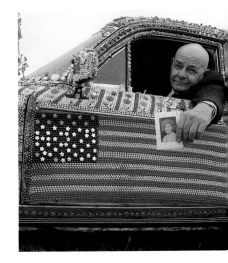

refused. When I photographed him recently, he glued on a handful of gold diamond rings. I asked him where he got them, and he told me that it has become a tradition of

sorts in Amarillo, Texas, where he lives, that people have been coming to him for years with jewels from their deceased relatives and asking him to add them to the "Jewel Box." If you ask him for details about one of the thousands of items on his car, he can tell you who gave it to him, what it's worth and why he put it on the car.

Jay lives alone in an apartment with his cat, Kit Kat, and makes a living by selling used cars in downtown Amarillo. He works on the "Jewel Box" about once a year.

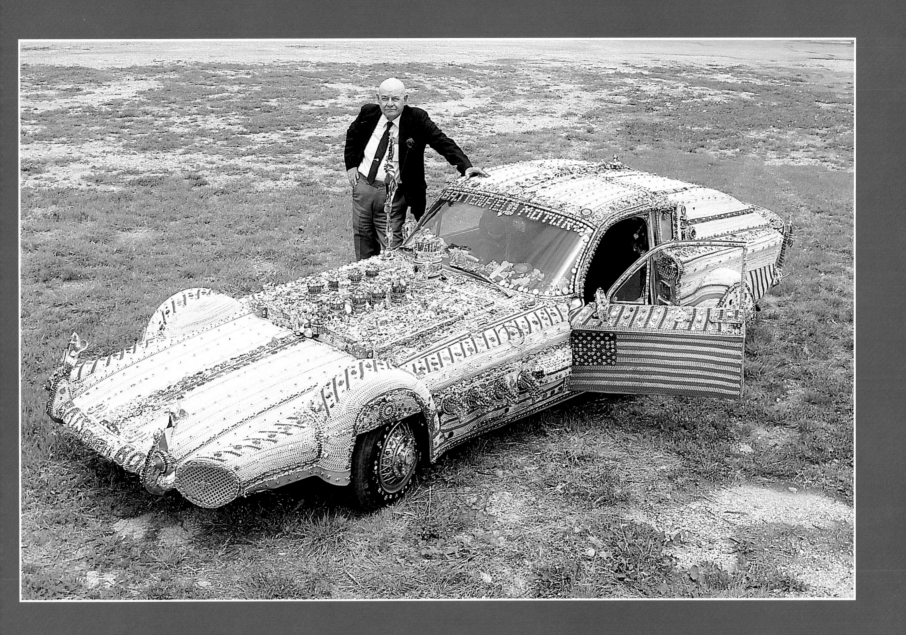

In 1984 an idea flashed in Eric Staller's mind: to create a car covered with lights. Only five months later he rolled the "Lightmobile" out onto the streets of Manhattan, which, he recalls, "was one of the most joyous moments in my life."

The "Lightmobile" has 1,659

LIGHTMOBILE

Eric Staller

lights, which can blink in twenty-three different patterns by the flick of a few switches of a computer control panel mounted on the ceiling above the steering wheel. The lights are powered by a forty-horsepower generator that rests in the cubbyhole behind the back seat. The only drawback to having the generator is that when it's running it makes conversation very difficult, especially if one is hearing impaired like I am!

Eric is a prolific artist known all over the world. He calls himself "a sculptor of light." He is expert in photography and has created many moving sculptures, which he calls "Urban UFOs." In addition to the "Lightmobile" he

has created the "Bubbleboat," a floating raft with blinking lights that resembles a spaceship; "Roly-Poly," a three-wheeled bicycle encircled by Plexiglas ribs that are covered with electroluminescent strips; and "Bubbleheads," a tricycle built for four peddlers, all of whom wear helmets that blink with hundreds of lights.

Obviously, Eric gets a lot of attention with his art. Some people think that the attention is the reason

he makes his bright blinking creations. When one's art is reduced to merely a means of getting attention it can be insulting. Eric talks about this in *Wild Wheels:*

"Well, you know, a lot of people would say, 'Oh, gee, you're just doing this for attention, you're just trying to get attention.' Well, I was getting attention, and yet I felt there were also an equal number of people or greater number of people who felt that I was giving *them* attention, that I had come to *their* street to give *them* something, that I was paying attention to *them*."

Unfortunately not everyone understands or appreciates art cars. Eric told me that once while he was talking to a group of people on the sidewalk next to his lit-up "Lightmobile," a man ran up to the car, jumped on top of it and began stomping on the lights. Eric pulled the man off the car and asked him how he could do such a thing. The man shrugged and said, "I don't know." I'm sure Eric didn't feel appreciated at that moment. Despite that experience, however, he continues to take the car out on occasion to give people a free show.

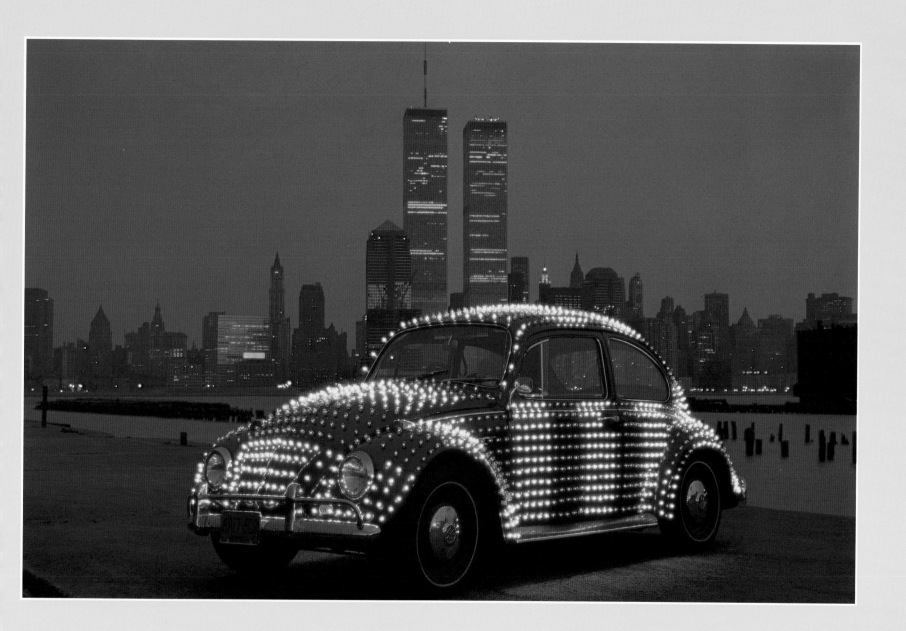

MAD CAD

Larry Fuente

Larry Fuente defines his "Mad Cad" as a "stained glass mosaic." Motivated by psychedelic religious visions and sometimes hallucinogenic drugs, Larry looks at objects in the world as little pinpoints of blurry colors that glisten and radiate beauty. He tries to recreate this beauty on things that normally

would be considered trash or junk. For example, he has embellished plastic ducks, a giant plastic cow, a plastic life-sized marlin and even several female mannequins, covering them with jewels, beads, sequins and knickknacks in a style similar to that of the "Mad Cad."

Larry designed the "Mad Cad" because he liked the idea that his art would be accessible to the general public and not confined to an art gallery. He chose a 1960 Cadillac Sedan de Ville because it represented the height of American opulence at that time. As he says in *Wild Wheels:*

"I wanted [the 'Mad Cad'] to be a caricature of . . . American society . . . to bring the whole yard, the American suburbs and the yard, out on the streets . . . the flamingos, the tailfins, the enormity of everything. Everything is overstated. Every item that I put on that car has a personal significance to me—either its color, its shape, its cultural significance, its size, how it relates to the whole rest of the car. Every object is an art object in itself. Every bead was designed by an artist, every little statue was designed by an artist, and, you know, it's now an eclectic statement. It's me jamming with every other artist, and the car itself was designed by a team of artists and so it is like a jam session of art."

The "Mad Cad" took over six years to complete. It has been displayed in museums and galleries all over the world, has been featured in hundreds of magazines (it appeared in a cover story of *National Geographic*) and has appeared in numerous parades, television commercials and books.

The car has many unique features inside. A large skylight in the ceiling that looks like a stained glass window is actually Plexiglas covered with colored transparent jewels. The dashboard has a collection of antique hula dolls that dance as the car rides, and the seats are cleverly upholstered with removable stuffed animals.

In Larry's hometown of Mendocino, California, the "Mad Cad" continues to get reactions even from people who have seen it a hundred times before. They still stop to marvel at it. There is something about the complexity of detail and the amount of labor that went into making this art car that just blows people's minds.

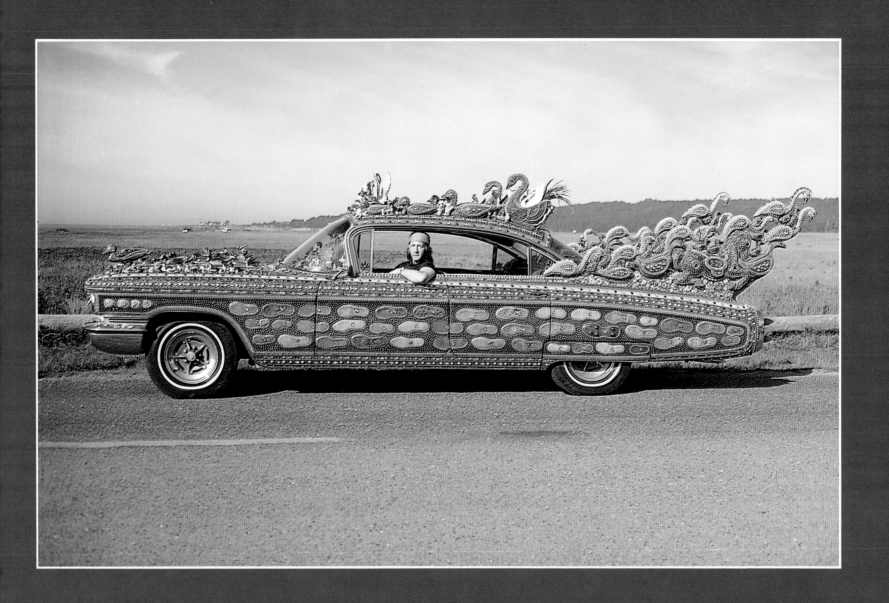

Many of Armor Keller's girl-friends were getting face-lifts at one time and she really didn't want one herself. On a cold January day in 1989 she decided to give her 1980 Toyota a face-lift instead. She began the painstaking process of gluing thin

Armor said that the attention she attracted in Birmingham, Alabama, where she lives, was incredible because hardly any

Roadside Attractions parades, Armor said her car was criticized by some because it looked plain compared to other art cars. Since then she has added new embellishments including thousands of pieces of mirror, hundreds of Day-Glo yo-yos, 600 pairs of Barbie doll shoes, lots of rhinestones and three pieces of gold leaf-decorated luggage on top. At the 1992 parade she won "honorable mention" for having one of the best art cars! She is still adding to her car and says she can't stop now.

MAGIC CITY GOLDEN TRANSIT

Armor Keller

sheets of gold leaf onto the car and within three months had it completely covered.

cars were modified there. At first she wasn't sure if she wanted to drive her car around, but gradually she began to like the attention and found that it really opened her up as a person. She says in *Wild Wheels:*

"When I'm in my costume and my car, I take on a whole new personality and have a lot of fun, and I can get out of my role as wife, mother, and I can become the real artist that I am."

During her attendance at the 1990 and 1991 Houston

MARBLE MADNESS

Ron Dolce

In 1976, using a brush and housepaint, Ron Dolce painted his girl-friend's VW bug white as a surprise birthday present. She enjoyed it at the time, but ultimately left Ron and gave him the car. He had a fender bender, but instead of buying a new bumper, he took the makeshift

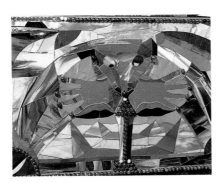

approach and made one by hand out of bamboo, abiding by one of his favorite Zen principles: "Bamboo gives in the wind, where the mighty oak breaks!"

After another accident ruined his front hood, Ron took a tube of

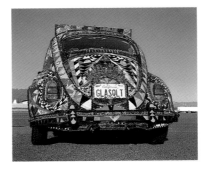

silicone and filled the ugly dent with marbles. Gradually, he came to view his car more and more as a work of art. Having studied art for many years, specializing in paint-ing, Ron uses his car as a canvas on which to express his visions. He defines glass as "frozen watercolor" and literally paints with bits of col-ored glass and marbles. His brush is the glass cutter and his palette is a box of scrap glass that he buys for very little from local stained glass shops.

Although he applied his first marble in 1979, Ron has still not completed "Marble Madness," also known as "The Glass Quilt." He works on it whenever he has a chance, whenever he isn't called to move furniture. It took him eight solid hours just to paint the 6 x 4 inch rectangular gas tank cover.

One of Ron's favorite stories has to do with his job, moving furniture. He drives "Marble Madness" wher-ever he goes, and when he reports to a job, sometimes the wealthy patrons are a bit shocked when they see his car. One time he had to go to Blackhawk, some thirty miles from his home in Oakland, California. Blackhawk is a housing complex in which each house is valued at over a million dollars and one must enter through giant steel gates and pass a security guard checkpoint. Ron drove through and parked next to a Jaguar,

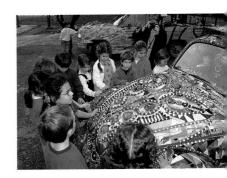

at which point an elderly woman came out and stared at his car with disgust. Ron smiled and said, "Don't worry, I'm only the mover, I'm not moving in!"

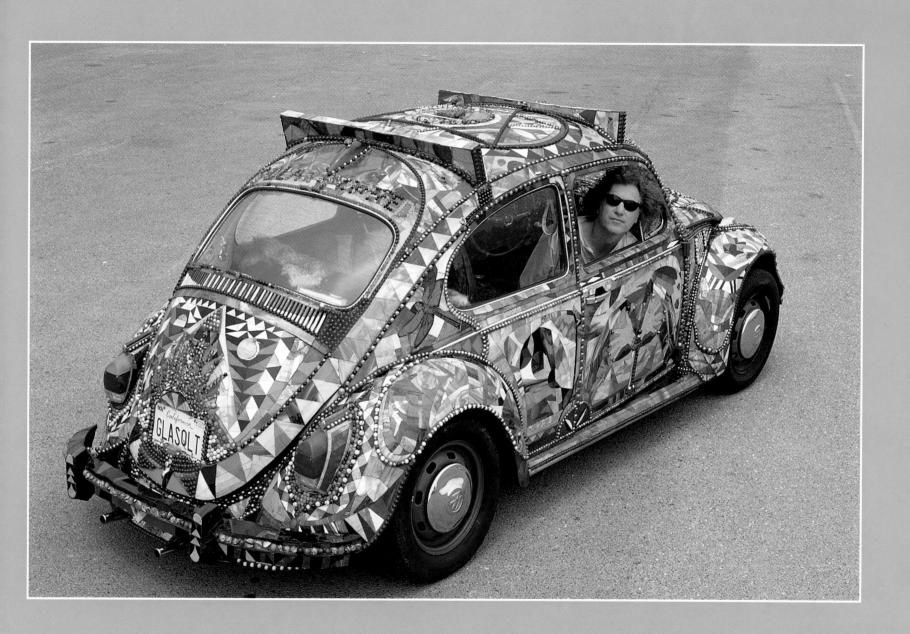

MIRRORMOBILE

Bob Corbett and Renee Sherrer

Bob Corbett inherited his father's 1970 Oldsmobile 98 and on the 4th of July he decided to modify it. He called up his friend Renee Sherrer, and the two of them planned to cover the car with Z bricks, thin finishing brick squares, to reflect the car's heavy, block-like design. Then they discovered that they had more mirrors than Z brick.

Bob sent me a list showing the exact statistics of all the labor and materials they used to make the car:

 72 hours of labor
 694 pieces of mirror
 4,164 double-sided tape
 squares
 5 tubes of "Mirro-Mastic"
 ½ gallon of Windex
 5 rolls of paper towels
 8 glass cutters
 2 Band-Aids
 26 Cherry Pepsis

Bob calls his car an "art rod" rather than an "art car" in order to bridge artists and serious motorheads together. He elaborates that many serious artists don't get excited about cars and many motorheads don't get into art. He considers himself a serious motorhead artist.

He likes to describe his car as the "shiniest Oldsmobile on Earth." His idea was for the finish to disappear and for the surroundings to become the finish. His dream is to drive the car down the Las Vegas strip at night!

Bob, an architect, lives in Butte, Montana, on top of an old ore bin he bought in 1972. He modified an abandoned zinc mill on the property. Because of the chemicals used to process the zinc, there is no vegetation anywhere nearby. His house has a state-of-the-art design, is solar powered and is called the "OXO Foundation." He drives a one-of-a-kind car and lives in a one-of-a-kind-house!

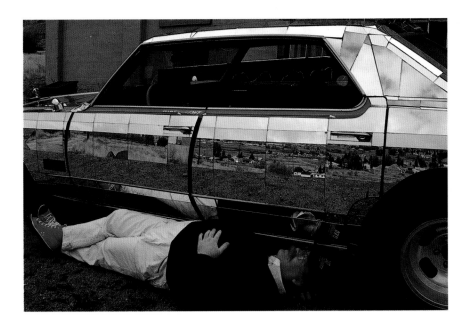

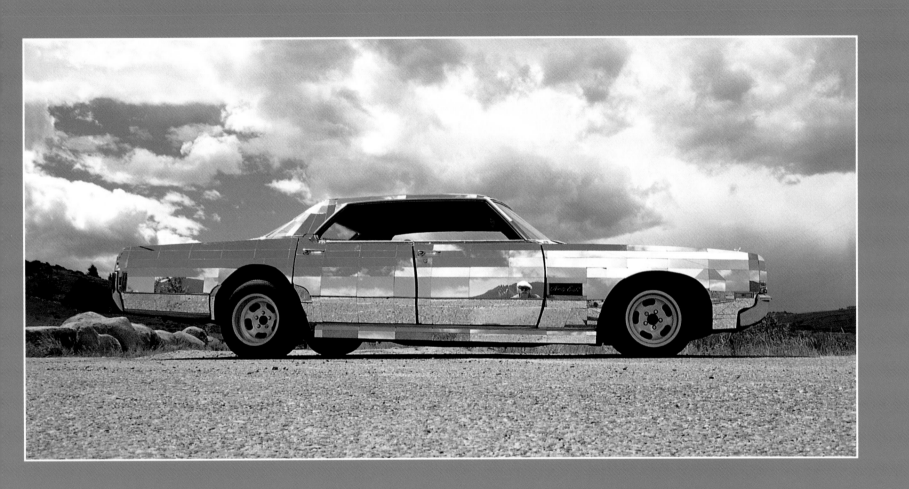

While in New Orleans to film the "Beaded Bug" and the "Cosmic Ray Deflection Car" I stayed at my mother's house. She has been extremely supportive of the film, so much so, in fact, that she decided to invest in it. One of her friends, Stella Farwell, took an interest in

MONKEYSHINES

Gail Blank and Stella Farwell

Wild Wheels as well and also became one of the film's investors.

During my visit my mother and Stella, who are both artists, couldn't resist making an art car. Bitsy and David Duggins, more friends of my mother, had a limousine that they wanted to sell. They decided that if it were an art limo it might be easier to attract a buyer. My mother and Stella collaborated

on a theme of monkeys playing with ribbons, and they painted it in a matter of a week.

David and Bitsy Duggins loved the new paint job and had a blast driving the limo around town. Convinced of the draw of car art, they, too, decided to invest in *Wild Wheels*. Then when they tried to sell the limo to the Audubon Zoo they were surprised to be rejected. After six months of advertising "Monkeyshines" for sale and receiving not one offer, David and Bitsy sadly elected to have the limo repainted in a traditional and professional manner.

My mother, Gail Blank, still resides in New Orleans, where she makes erotic ceramics, and Stella Farwell lives in Captiva, Florida, where she creates surrealist floral paintings.

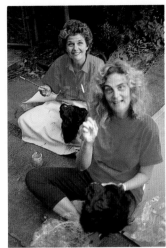

Stella Farwell and Gail Blank

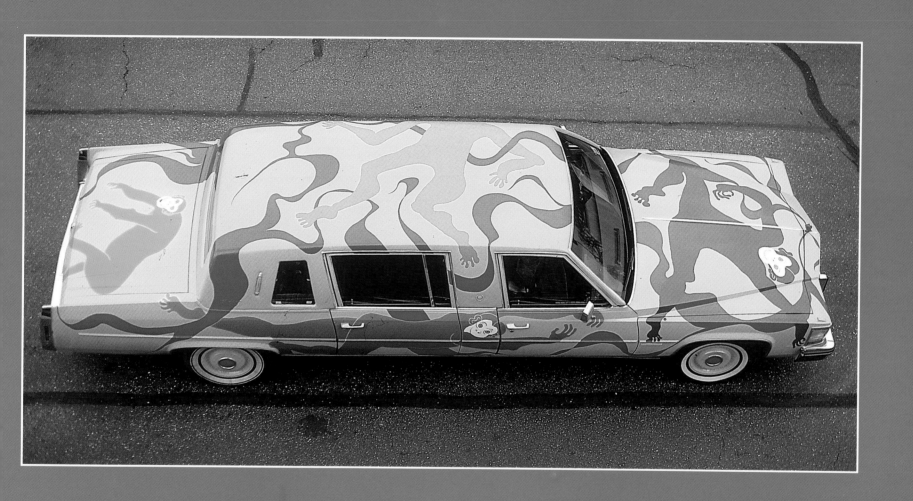

As I described in the introduction, my car has evolved over many years. It began as an all-white VW bug, then became a reggae-oriented "Rasta Bug" and finally, after the addition of all sorts of gadgets and moving parts, is now called "Oh My God!"

OH MY GOD!

Harrod Blank

Each part of the car is special in its own way. On the left side of the front hood is a poem I wrote for a girlfriend who was leaving town to encourage the chance that we

would see each other again. I painted it on the car so that the poem would apply to everyone who sees the car. On the right side of the hood is the word "peace" painted

by hand in twenty-six different languages and counting. Every time I hear someone standing by the car speaking a foreign language, I ask him or her to paint "peace" on it in his or her native language. A plastic world globe serves as a hood ornament; it lights up and blinks by the flick of a switch. There is a variety of fruit and vegetables attached to the front bumper for no other reason than that it adds color and I like to eat fruit. Where the VW emblem used to be, three grasshoppers are placed on top of each other as a symbol of fertility. The Santa Claus below the globe is a symbol of giving, and the bone on the bumper represents the primitive nature of the car.

On top of the car is a TV set that I shot with a .22 rifle on the side of the road in 1986. I got sick of seeing commercials and have not owned a TV since. Inside the TV, a doll represents sex, squirt

guns depict violence, a monster is for sensationalism and a skull is for what happens to people when they watch too much TV! The skull glows in the dark and flashes with light at night, as do all the squirt guns. An orange blinking light in the back of the TV lights up the whole screen, giving it a hellish appearance at night.

To the right of the TV is a mailbox for messages, of which I have received many—including a couple of marriage proposals and a threat from the KKK. Shooting upward from behind the TV is an American flag, which I would like to change to an Earth flag or something more universal. On the driver's door is a rooster representing my past with chickens, and on the passenger's door, left over from the "Rasta

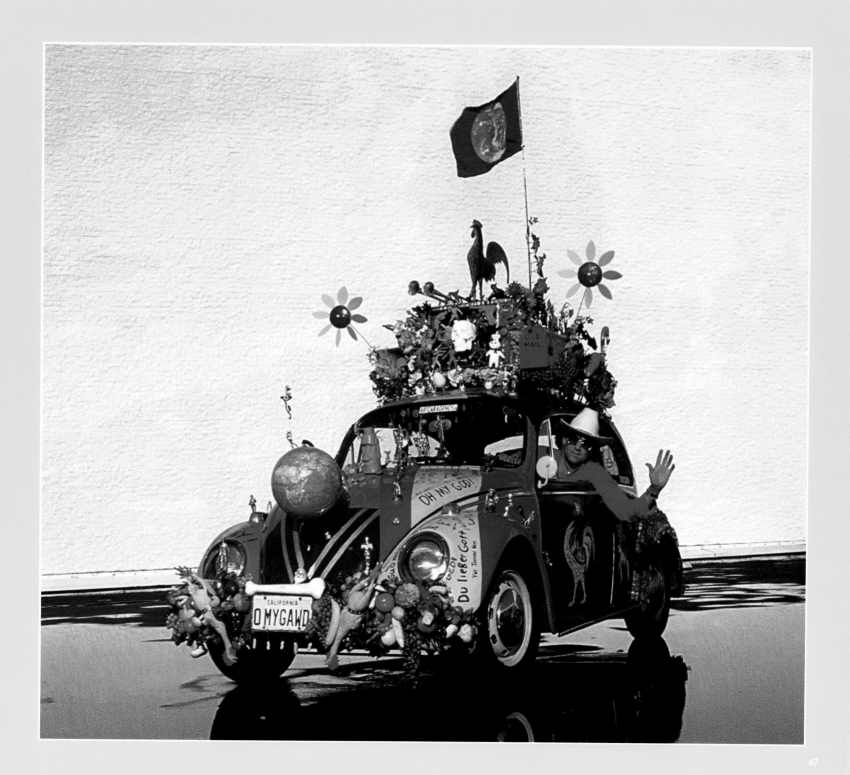

Bug," is a portrait of Bob Marley to represent "human freedom."

The back engine flap has been converted into a chalkboard with an accompanying eraser and a pouch of chalk for people to leave messages. Behind the TV set

is my version of the "Garden of Eden," in which all animals live in harmony. The humans in this "Garden" are the smallest and the mouse is the largest. Plants and flowers are growing up over the TV set, a sign that nature is trying to take over the machine.

On the passenger's side behind the portrait of Bob Marley is the popular "chicken button." When pushed it makes an extremely loud sound of cacophonous chickens for exactly fifty seconds before shutting off automatically. Sometimes I forget to turn down the volume in front of the house where I live. As a result

many of my neighbors have complained that the car wakes them up in the morning! I will be installing more buttons that do bizarre things in the near future so that the public can be fully entertained by pushing various buttons.

On the inside of the car there is an art gallery beneath the back window, and stuck above on the headliner is an array of minute objects that have been given to me. On the dashboard are little things that move, flowers, fortune cookie slogans and all sorts of little knickknacks.

Since I began making *Wild Wheels* I have been directly influenced by several people and their techniques. The Fred Flintstone doll and other plastic objects on the hood light up and blink, a trademark of the "Toy Car Limo" by Darrell the Clown. I created the rear fender on the driver's side after seeing Larry Fuente's "Mad Cad." I call it the "Rainbow of False Security," and it is made up of purple and blue miniature cars, gold coins, green monopoly houses and red poker chips—all symbolizing wealth. I glued the objects together meticulously like Larry did, in rows of different colors. At the end of this rainbow is not a pot of gold but a

skull, which is to say, if money is all one lives for, then one is part of the living dead.

Many people have given me things to put on the car, and many friends including Kevin Ratliff, Danny Orozco, Karen Baker and David Silberberg have contributed to the building of the car. Kevin, for example, not only named the car "Oh My God!" but also thought of the chalkboard idea and has helped sand and paint the car over the years.

The car is always going through changes. On the roof, for example, I started out with a giant Raggedy Ann doll, which was replaced by a Wylie the Coyote doll, which was replaced by a large TV set. But when I find something I really like, I won't change it. Rather, I will maintain it.

I have had a world globe hood ornament on the car since 1985, but it took about four years and over twenty different kinds of globes to figure out the best brand and the best way to attach it. I started out using a cheap cardboard globe, but no matter how much I waterproofed it, water would leak into the hole where it spun and ruin it. Then I discovered the plastic light-up globes. They

were better in the rain, not to mention the fact that they lit up and could flash at night. I thought I finally had it all figured out when one day while I was driving on the freeway the metal stand broke and the globe flew off the car. I watched in my rearview mirror as it bounced down the freeway making cars swerve all over the place. After a few more tries, I figured out how to make a stand that would hold up and I thought I would never have to replace the globe again, only the bulb from time to time. Then some guy decided to punch the globe and his fist got stuck inside. Because the globe is made out of hard plastic, when he pulled his hand out it was all cut up. I had to spend $80 to buy a new globe and make all sorts of adjustments to make it fit on right.

For some reason "Oh My God!" seems to have attracted more cops than any other art car. I have been given fifty-one of the stupidest tickets anyone has ever heard of, such as "impeding the flow of traffic," "carrying an unsafe load," "having impaired vision caused by globe on hood," "no light above license plate" and "loud noise of chickens from external speakers!"

One of the most absurd tickets I ever got was in my own hometown of Santa Cruz, where I have been pulled over by virtually every cop on the force. I had bought a miniature toy trailer that was silver colored and streamlined like a Winnebago. It was two feet long and about ten inches wide. I hooked it up to my rear bumper with a spring so that when I turned a corner, the trailer would go around it, gliding along perfectly on its four little wheels. It was great. Everyone was going crazy waving at me, pointing and laughing. The energy was high and I was having a ball driving around.

After about two hours of sheer ecstatic fun, a police car flashed its

Harrod Blank and Kevin Ratliff

lights behind me. I stopped the car and couldn't imagine what I had done wrong. The cop approached with a slow, macho gait, looking

the car over with disdain. Then he slowly lowered himself, leaned into my window and said in a dead-serious tone, "Okay, where's your license and registration for the trailer?" I laughed and said, "Oh, come on, you gotta be kidding." "If you don't remove that trailer right now," he said, "I am going to incarcerate the car!" I walked back to the trailer and ripped it off in a burst of frustration. Can you imagine that? I have been pulled over so many times, it has become routine. Now whenever I even see a cop car, I automatically pull over!

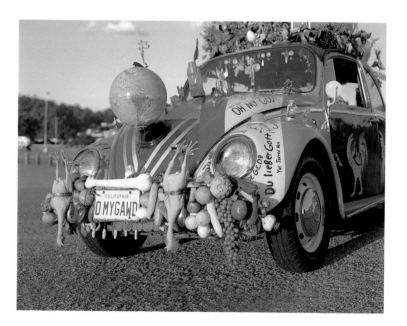

The "Oozemobile" is a unique art car in that it is a conglomeration of work by seven different Houston artists. Each of the following artists picked his or her own section of Carter Earnst's car on which to create: Carter Earnst, Paul Kittelson, Jackie Harris, Noah

OOZEMOBILE

Carter Earnst and Friends

Edmundson, Steve Wellman, David Kidd and Donald Quarles. The car features all sorts of different objects and styles of application

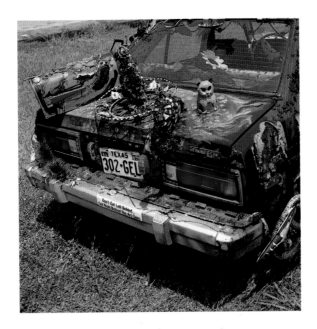

including a pinkish "ooze" made out of foam spray.

After participating in several annual Houston Roadside Attractions parades, the "Oozemobile" has become defunct and now sits in the back of Carter's house providing a "cool" shelter for her wild dog, Grover.

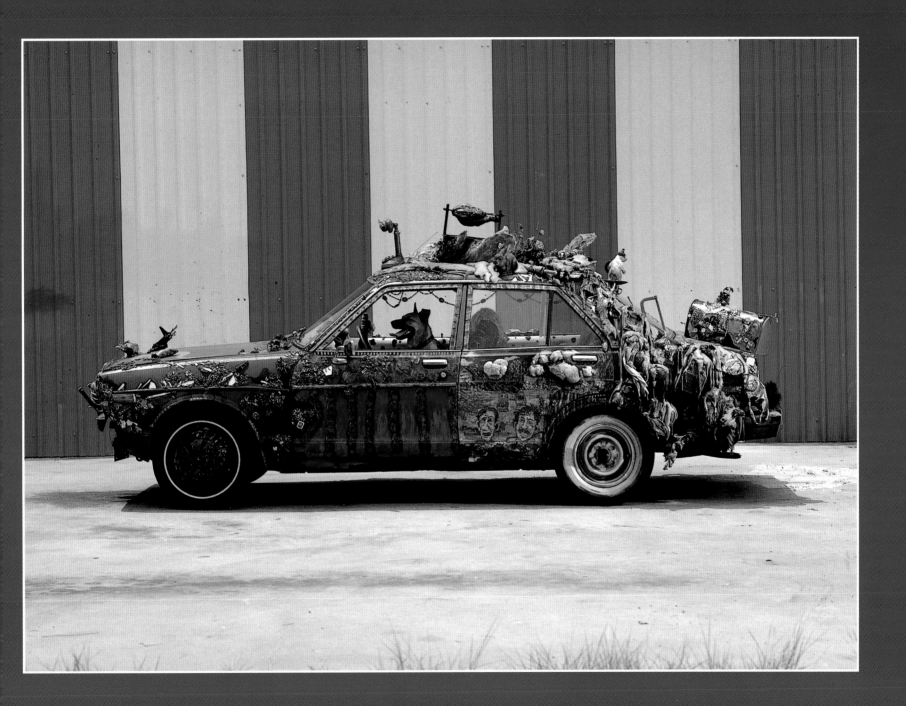

OUR LADY OF ETERNAL COMBUSTION

Reverend Charles Edward Linville

In Portland, Oregon, Charles Linville awakens every day at 5:30 A.M. to deliver the mail. No one would ever suspect that the neighborhood mailman is the one responsible for the old American car covered with bizarre bric-a-brac, hundreds of rubber nipples and a sign that reads "Beware of God!"

Charles enjoys his semi-secret hobby. He's like Clark Kent, who changes into Superman. When he gets home from work, he practically rips his off his mail carrier's uniform to become his free, wacky self. Besides working on his car, he has several other bizarre hobbies. The strangest, in my opinion, is his fascination with stuffed poodles. He showed me his basement, in which there must have been over 200 poodles of all different colors, shapes and sizes. His favorites are the pink poodles because they are so gaudy.

In addition to having one of the world's largest collections of bizarre records, Charles is a bona fide registered Reverend and has actually married six couples in his car. Every year he participates in and helps coordinate the Portland "Beater Car Club Picnic," an event that attracts a lot of art cars. "Beater" is a term coined by Reverend "Beater Bill" Lockner, one of Charles's friends, which basically means a car that has been beaten up to the point at which it becomes art.

Charles credits his father with having influenced him to make an art car. "Whatever my father did I wanted to do because I looked up

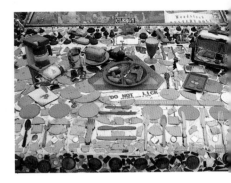

to him. He used to drive this custom goofy golf cart that he designed, and I would ride around with him a lot and I thought it was really neat. I think that's why I started making my car different."

In *Wild Wheels,* Charles tries to get liability insurance for his car and is turned down because it is an "attractive nuisance" and could cause accidents. At this writing he is still uninsured and no one will offer him insurance. It is ironic that in the five years that he has had his art car he has never been in an accident or caused one. I have learned that the key to getting insurance for an art car is to insure the car before decorating it!

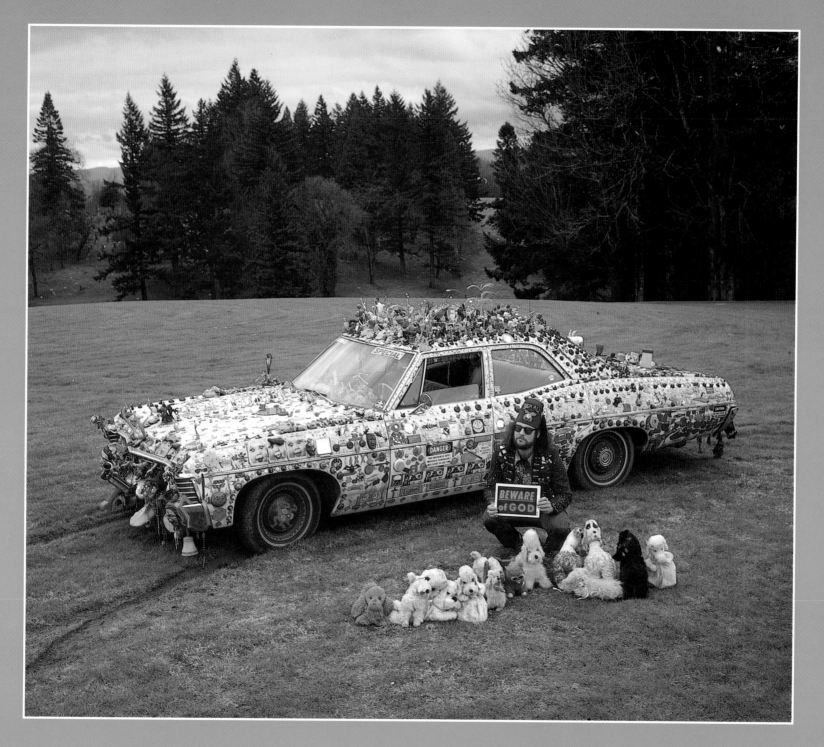

POSTCARD TRUCK & HOME ON THE STRANGE

Dr. Atomic

In 1986 Dr. Atomic had become fed up with car commercials and the attitude that a new car was "a godlike thing." He decided to protest the commercialism of American society by taking his extensive postcard collection and gluing it onto the exterior of his truck. People came up to him afterward and expressed disappointment that he had "ruined" such valuable, hard-to-find postcards. Others complained that he had defaced a beautiful Chevy pickup.

These comments only further convinced him that society was screwed up and that he was doing the right thing.

After four years, the Doctor decided to remove the postcards for

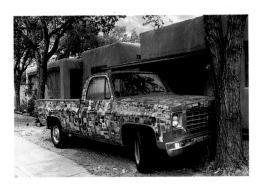

two reasons. First, he had become bored with the postcards. Second, he was frustrated by the high level of maintenance they demanded. After years of experimentation, he had mastered the techniques of postcard application and preservation, but he couldn't prevent the sun from fading the cards. He didn't have a garage, and he didn't want to cover the truck with a tarp, as that would have been more of a drag than it was worth.

In 1990 Dr. Atomic became the first person known to make two drastically different art cars out of one automobile. He went with a New Mexico theme and covered the truck with pinkish stucco out-

lined with hand-painted terra-cotta tiles. He chose stucco so that he would never have to maintain it. He called it "Home on the Strange."

The truck also features a wooden dashboard, wooden bumpers, vigas that stick up above the cab and a living cactus affixed to the bed. The inside of the cab is completely tiled and features a mosaic of a lizard on the ceiling.

Dr. Atomic is presently studying to earn a Ph.D. degree in ceramic science at the University of New Mexico in Albuquerque. He has only three classes to complete before he becomes a "real" doctor.

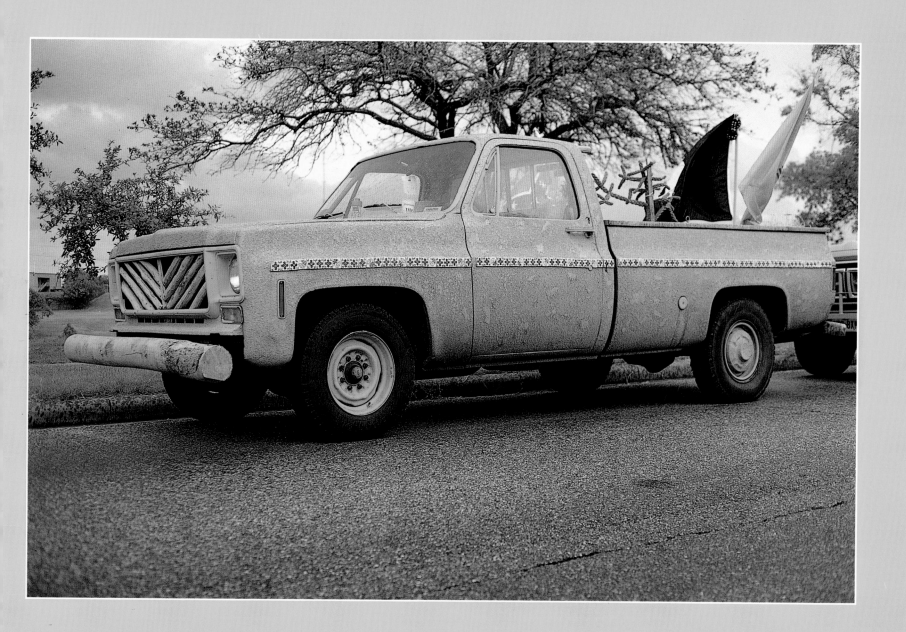

SUPER COUPE

Theo Althuiszes

Sometimes I find people who have made art cars, and other times they find me. In 1989 Theo Althuiszes had read an article in the *San Jose Mercury* about a show I was doing in Santa Cruz on car art. He came to the show and brought his art car, which resembled a spaceship. I was intrigued, as I had never seen anything like it.

When Theo was a boy in the Netherlands, he was fascinated with flying saucers. Then he moved to America, where he dreamed about them until he had a UFO experience. A craft came down over a friend and him and shined a light down on them. He said that it was such an intense and real moment that it convinced him of extraterrestrial life. He began reading all the books he could about UFOs and life beyond Earth, and he is still searching for information today.

Theo did not consciously make his art car to look like a spaceship.

It was a practical undertaking, to make it more livable and something that was his space. The exterior is fiberglass that he shaped himself and has some spray-painted designs scattered about. The Gothic windows open in the back to reveal a futon inside with incense holders and images of the Buddha on the walls. The inside, where he spends most of his time, has had the most work done on it.

The steering wheel displays a variety of ornate objects and is a good indicator of Theo's unique taste. The dashboard features an assortment of religious icons from all over the world, which reflect his deep spiritual curiosity, and a string stretched from one side of the car to the other carries a long line of key chains that dangle forward and backward as he drives. It is very peaceful and comfortable riding in the car. Even in rush hour traffic it is mellow. It conveys a feeling of being in a different reality— like when watching a movie or maybe being in a spaceship.

This brings up a serious point. Driving an art car all the time can make the driver feel like an "alien" or out of touch with reality. Imagine eyes everywhere looking at you, inspecting you and probing into

your soul, discerning eyes, eyes that ask the question, "Why?" How would you feel after five years of those piercing eyes? The result is that one can become highly introspective, insecure and withdrawn. I can tell you from years of experience that it is very difficult to maintain one's sense of reality after driving nothing but an art car for more than a year or two.

Theo drove only his "Super Coupe" for five years, and he was much relieved, as I was, when he acquired a second car to drive around. It is much easier when one can choose between driving an art car and driving a normal car. Sometimes it's nice to be anonymous.

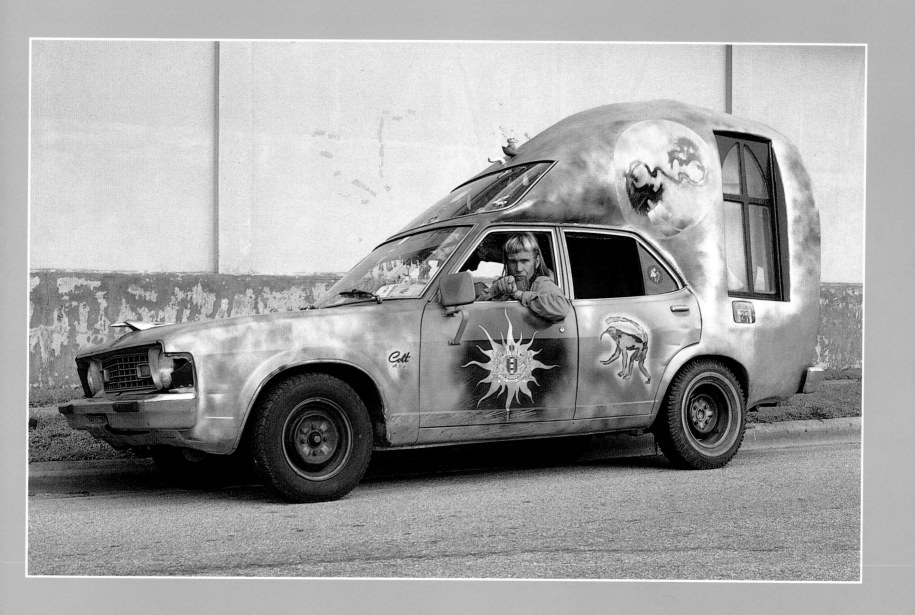

TO LIFE

Russ Aharonian

Russ Aharonian originally worked in construction and created art on the side. Struggling to survive as an artist, he created "To Life" to attract attention to himself, and especially to his art. What motivated him to create, he says, is what motivates many artists: the complex relationship between men and women. "There's a lot of eroticism on the car," he says, "and also a lot of philosophical quotations, though you have to look close to see them." He added the personalized license plate "To Life" to represent his philosophy that it is important to celebrate and enjoy life.

Russ said that the car liberated him at first, giving him freedom to

express himself and be who he wanted to be. Gradually, though, the constant attention began to wear him out—he had had enough.

Then he wanted a different kind of liberation—to be invisible! The car eventually broke down and Russ never fixed it. A flourishing garden

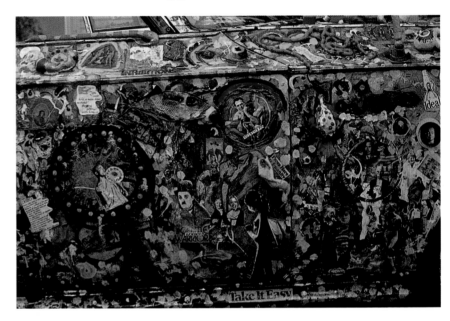

grew up, over and around it.

What replaced "To Life," perhaps, was more intimate contact with people, as Russ became a massage therapist. He now practices out of his home in Kittery, Maine, and continues to work as an artist as well.

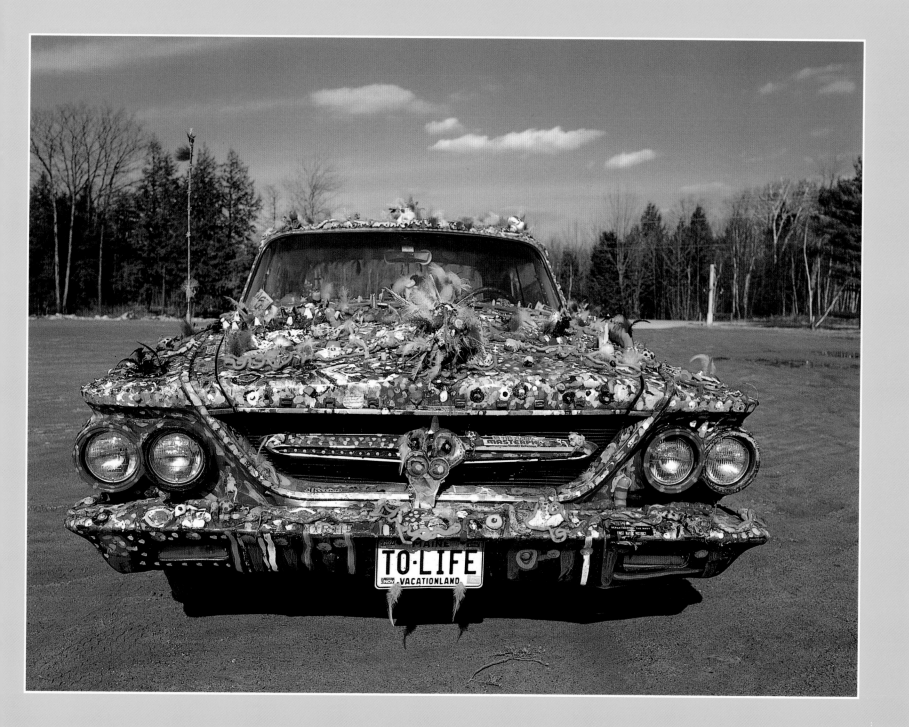

TOY CAR LIMO

Darrell "the Clown" Holman

When Darrell was a boy his father didn't show him any love or affection. If he did anything wrong at all, his father would beat him with a willow stick or a belt. Eventually he began doing bad things on purpose because he wanted to be beaten—it was the only form of attention his father would give him.

At age sixteen Darrell decided to run away from home forever. After hitchhiking across the country a few times and doing odd jobs for ten years, he eventually became a professional clown.

Darrell made Austin, Texas, his home for most of his life, and it was there he created his famous "Toy Car Limo." For years he parked it every night on Sixth Street in downtown Austin and entertained the passersby. He never charged money to see his art car and accompanying clown show, though sometimes he was given donations. He told me that he did it for the kids, to give them the love he never got as a child.

Many of the toys on the car light up and blink at night and/or do little tricks by the push of a button or by the wind of a key. Darrell entertained people, all dressed up as a clown, by orchestrating a performance of all the toys operating in succession. Then he would take a break and allow the children to activate the toys themselves.

Darrell fought to survive the last few years of his life with a "bad heart" and told me that he was waiting for the premiere of *Wild Wheels*. He had moved to Provo, Utah, to be with his sisters and remaining family, and he was hoping the film would be accepted into the nearby Sundance film festival held in Park City, Utah. Unfortunately, the film was rejected by the festival on the grounds that it "lacked social depth." Darrell passed away six hours after I reported the bad news.

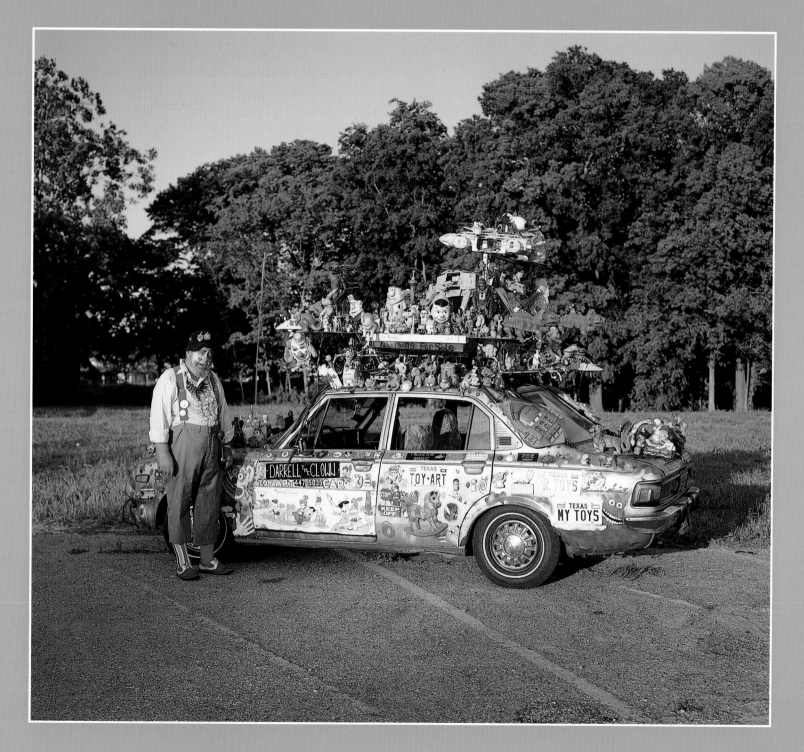

TURKEY TOYOTA

Ramona Moon

In 1978 a group of people collaborated on what was called the "Unknown Museum," which housed a collection of art made from found objects, unique memorabilia and household junk. Among these people were Mickey McGowan, Dikens Bascomb, Larry Fuente and David Best. They also all worked together making art cars and driving them around in Marin County, California, showcasing them at an event called the "Automotive Fashion Show." Ramona Moon attended this event and was so impressed by the art cars that she went home and began sticking toys onto her car.

Ramona created the "Turkey Toyota" over a period of fourteen years. She feels that it will never be finished, that it is an ongoing process. She works with toys simply because she loves children. What better way to attract children's attention than to cover a car with toys?

Ramona is a Montessori schoolteacher in San Rafael, California, where she lives, and she has been teaching two- and three-year-olds for over ten years. She also teaches art to children ages three to six. She has a son,

Lucian, who grew up riding in the "Turkey Toyota." She says that he has gone through phases of liking the car and not liking it, but that at sixteen he is an incredibly talented cartoonist and the car has played a key role in influencing him.

Ramona spends a great deal of time maintaining the car because many children take the toys! She uses Dap 2000 construction adhesive caulk, which she applies with a caulking gun. She is adamant that it is the best adhesive and that it is a very reli-

able means for sticking objects onto a car.

Since I have known Ramona, she has had several expensive mechanical misfortunes. For example, her engine had an oil leak, but when the little red indicator light came on, she didn't know what it was and continued to drive. One mile later, her engine froze up and suffered a meltdown. The repair bill for rebuilding the engine and adding a new front end cost her $4,600! When a person creates an art car and invests a lot of time and love in it, the car becomes a bona fide part of his or her soul. Ramona once told me, "When my art car breaks down, I break down. . . . I will do whatever it takes to get it fixed!"

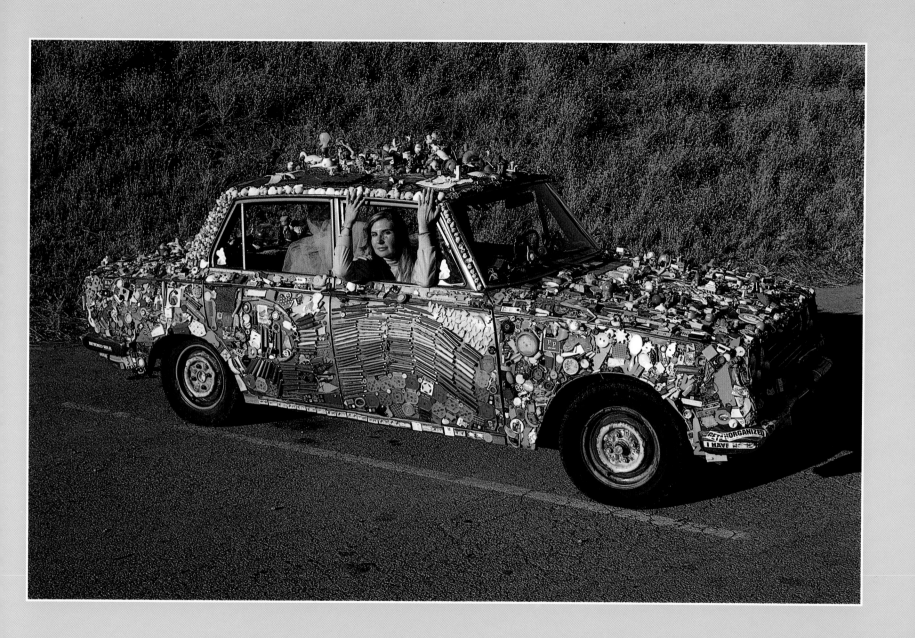

ULTIMATE TAXI

Jon Barnes

Pretend that you are in Aspen, Colorado, on a ski trip. It is late at night and you need a taxi to get back to wherever you're staying. You look in the phone book and see the "Ultimate Taxi" listed, so you call that one. A normal-looking yellow cab shows up. When you get in

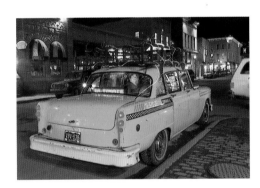

the back, white fog spills over your feet, a glistening mirror ball spins from the ceiling and Jon Barnes looks back at you with a cheery face lit up by flashing theater lights and says into a microphone, "Welcome to the 'Ultimate Taxi!' You are aboard the only recording studio, theater, nightclub, planetarium, toy store taxicab in the world!"

Then Jon pulls away from the curb and begins his show—a com-

bination of singing, playing music and performing a laser light show—all the while driving you to your destination! At the end of the ride he hands out free liquid light necklaces, glo toys and prism glasses. Then he says, "On your way out, don't forget to stop in at the souvenir shop, conveniently located in the back of the trunk!" He hops out, pops the trunk and unveils an assortment of T-shirts and fun gadgets for sale.

It all started in October 1986, when Jon began driving a taxi. After two and a half years, he decided to try to make his job more fun for himself by installing a Yamaha portable piano in the front passenger's seat. For a year he taught himself how to play the piano, practicing late at night while waiting for customers between fares. Gradually he became good enough to play while driving customers around. Then a friend, Bob Zook, suggested that he add some lights to his show. In 1989 Jon added some theatrical lights, a mechanical rotating mirror ball and a fog machine that pumps fog under the backseat.

Today the "Ultimate Taxi" has even more additions. Instead of having only two pedals on the floor, a brake and accelerator, there are

now four. The "drum pedal" controls a digital drum machine, and a "sustained pedal" controls the resonance on the grand piano. Other features include four-circuit tube lighting that follows the lines of the car, 1,000 glow-in-the-dark stars on the headliner, an electronic

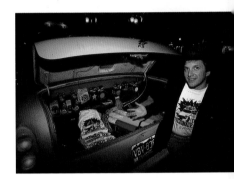

Yamaha flute and saxophone, a message sign on display in the back window, neon sticks and fiber optic side-lit tubing, pattern lasers and all sorts of glow-in-the-dark toys and objects to play with!

One of the best entertainment values in Aspen today, a ride of up to a half hour in the "Ultimate Taxi" costs just $15 per person, which includes photos and souvenirs for each rider.

Jon says he initially just wanted to have fun giving people rides in the taxi. Now he wants to see what kind of ride the "Ultimate Taxi" takes him on.

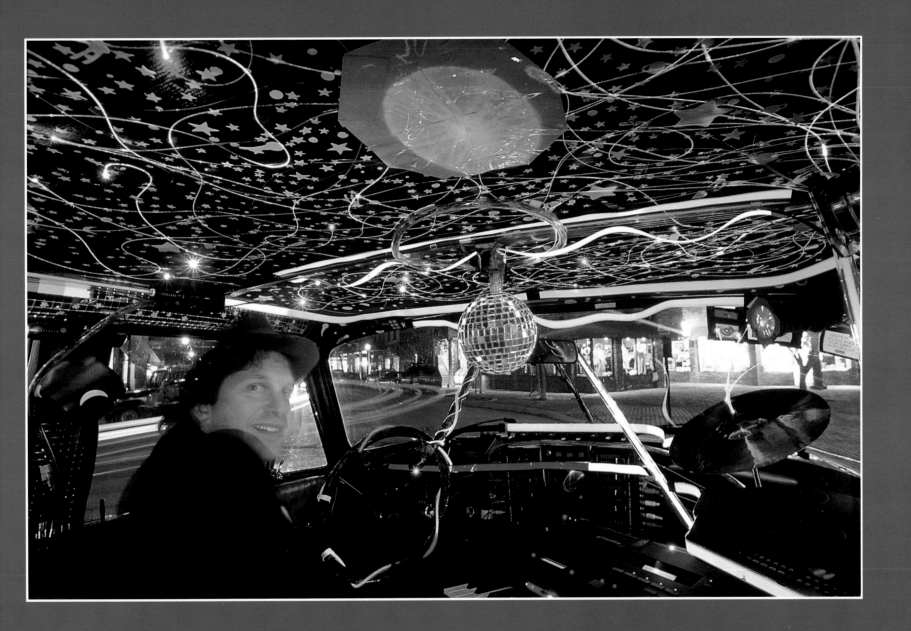

One day Suzy Daughtry realized that she just wasn't happy making a "decent living" and running several businesses. She figured that there must be more to life than just making money, so she flat out quit. She spent a year fishing and then decided to go to Mexico and try her

gained so much publicity with her truck and met so many important individuals along the way that she

began getting commissions to make sculptures. After a year, she decided to go back home to Dothan, Alabama, where she

started her trip, realizing that she had always taken her hometown for granted. She still drives "UMO" around town and has since created a VW art car and a little trailer, not to mention a bicycle. Suzy boasts now that she has her own art car parade right in her backyard!

UNIDENTIFIED MOVING OBJECT

Suzy Daughtry

hand at sculpture. After three years of living in Puerto Vallarta and making her trademark white stucco sculptures, she had developed a reputation as one of the foremost female artists in all of Mexico.

When she moved back to the United States, however, she couldn't get any galleries to show her work because no one knew who she was. She designed "UMO" and set off on a six-month road trip to find a place to work and establish herself all over again.

Her plan worked. Suzy

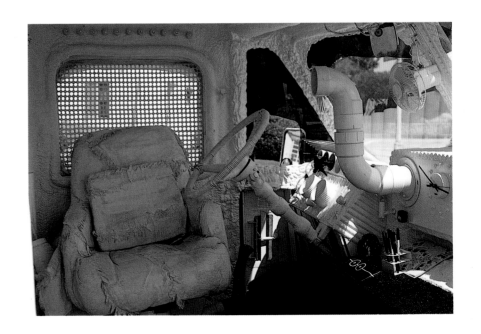

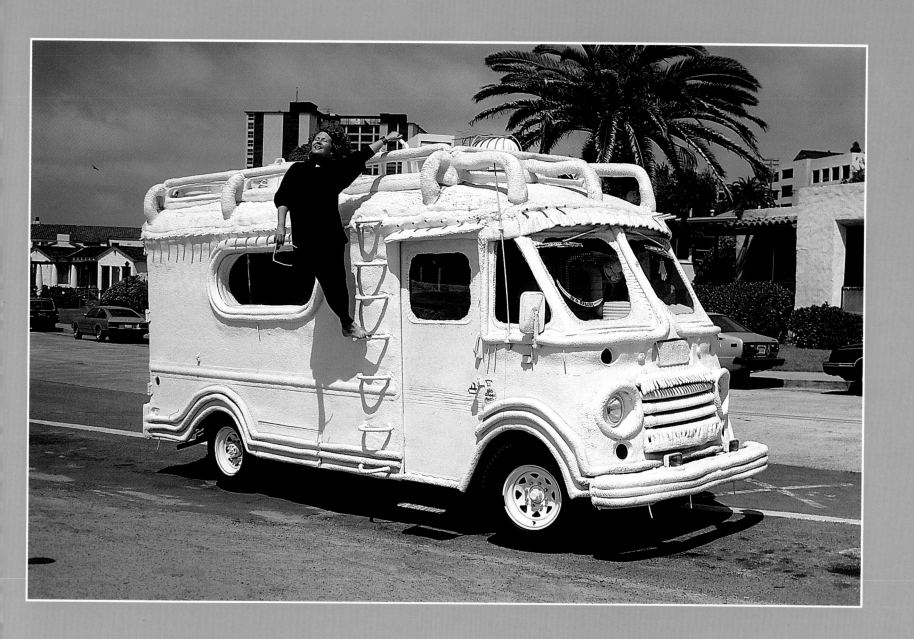

One of the only Saabs I have ever seen made into an art car, "Urv" is a wild, abstract concoction of spray-painted symbols representing industry and its chaotic, mechanical moving parts. The car was created in Houston by artists Pati Airey and Steve Wellman and

URV, THE PSYCHEDELIC SAAB

Pati Airey and Steve Wellman

has since ended up someplace else. I'm not sure where. Pati Airey is presently living and painting in San Francisco.

88

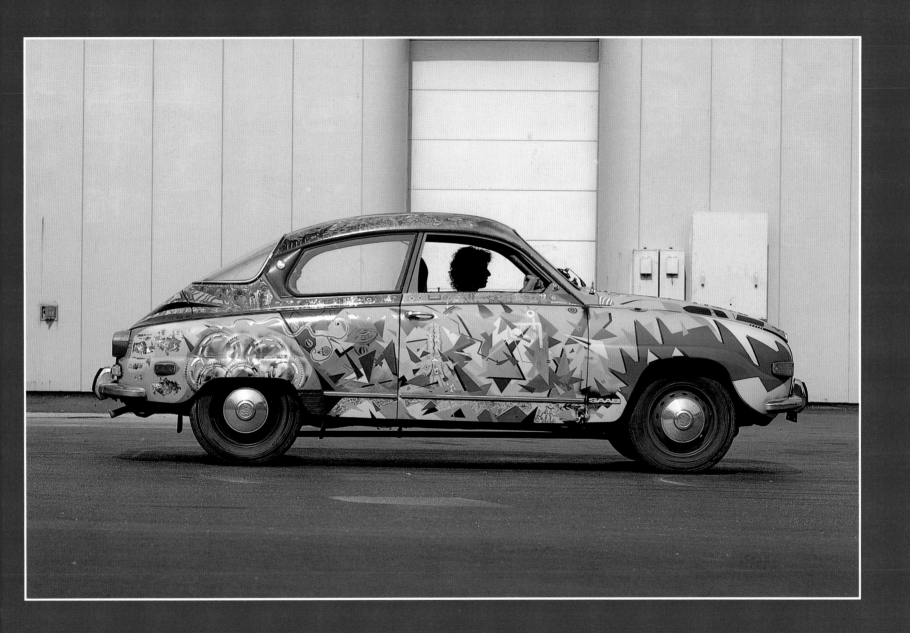

WHALE CAR

Christian Zajac

Christian Zajac began making his art car at about the same time I began making mine, when we were both freshmen at the University of California, Santa Cruz. Some people thought we were in competition with each other, but that wasn't the case. We sometimes would park the cars by the lighthouse and work on them together.

Christian said he started painting on his car because he ran out of canvas. After painting all over the car, adhering to an ocean life theme, he made an eight-foot-long fiberglass pilot whale fin and attached it to the top of the car.

At one point he attached a ling cod head on the hood and rigged it

so that when he pushed the windshield wiper button, water would squirt twenty feet out of the fish's mouth. One night the head disappeared and he thought it had been stolen. He later figured out that an opossum had snatched it!

Unfortunately, the "Whale Car," which was featured at the end of my first film, *In the Land of the Owl Turds,* was taken to the Santa Cruz city dump because its rusted body was in such bad shape that it couldn't be repaired.

Christian is a commercial fisherman living in Santa Cruz. He continues to paint and is looking forward to making another art car.

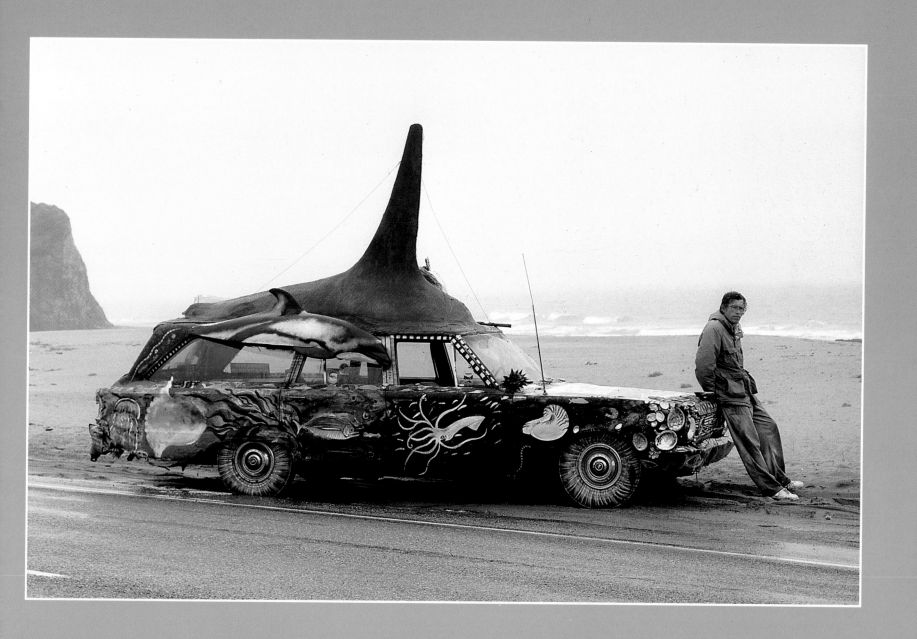

When we went to visit Joe Gomez in San Antonio, his incredible "Wrought Iron VW" was sitting on his front lawn covered by a blue tarp. I asked Joe why he kept it covered, and he said that the car was making his wife jealous because so many women wanted to ride in it!

WROUGHT IRON VW

Joe Gomez

When we filmed him he had recently suffered a heart attack and was recovering. He told me that he had gotten so many customers at his wrought iron business as a result of his car that he overworked. After his heart attack, he decided to quit making wrought iron and ironically got an office job selling life insurance. Now he has retired from that and spends time raising chickens and honeybees.

He tells this story in *Wild Wheels* about building the "Wrought Iron VW" :

"One day when I was in bed, we were asleep, and all of a sudden I sort of woke up because I had this dream. I was dreaming that I was actually building this car. And I, uh, got up and my wife sort of—I scared her—and she said 'Did you hear a noise?' And I said 'No!' I said, 'I am going to build a car.' And she said, 'What?' I said, 'I am going to build a car!' And I ran to the kitchen and got some paper and started sketching what I had been either daydreaming or actually asleep dreaming. . . . Everyone thought I was crazy; even my wife thought I was going crazy. It's like I couldn't sleep, I just had to build that car. . . . It started taking shape, then she says, 'I know we can do it!' And then she started helping me out. . . . The reason I chose the Volkswagen is because the motor's in back—otherwise I'd have all the fumes in front. It took me a little bit better than nine months. It's just like

a baby. . . . Everything on this car is handmade, nothin' is factory."

Joe now has a concern about what to do with the car after he dies. He has several children and does not want them to argue over who gets the car. He would like to sell it for a good price so that the money can be more easily divided.

Joe told me that he was deeply saddened when he found out there was a wrought iron VW in Santa Barbara, California, and another one in Ciudad Juarez, Mexico. Can you imagine VW bugs made out of wrought iron by three men who had never met or heard about each other? Maybe Jung's theory of the Collective Unconscious is true!

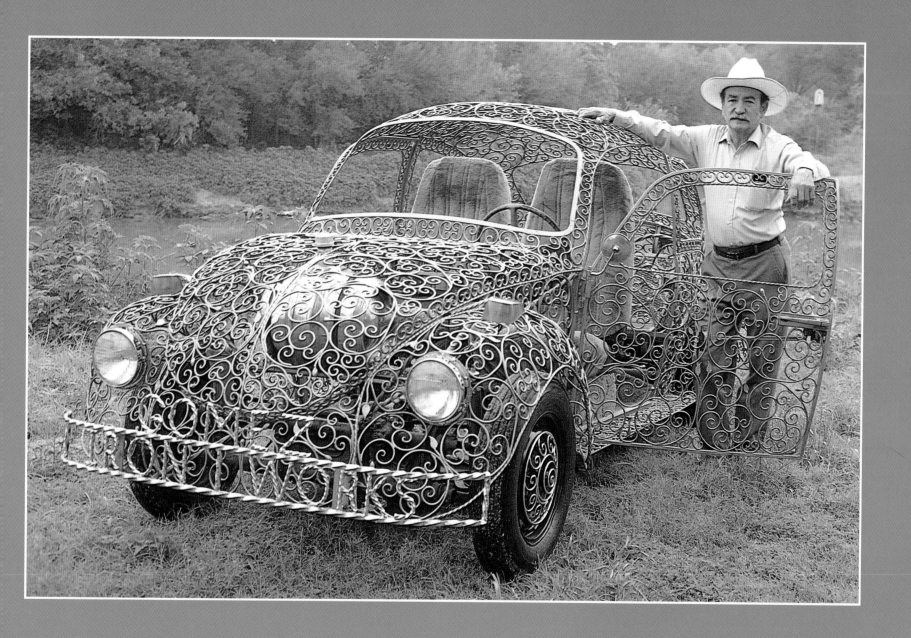

To see over 100 more Art Cars,
check out Harrod Blank's second book!

Harrod Blank
art cars
The Cars, the Artists, the Obsession, the Craft

Art Cars:

The Cars, the Artists, the Obsession, the Craft

Available from:

Lark Books

67 Broadway
Asheville, NC 28801
(800)284-3388
www.larkbooks.com

Photo Credits

All photos by Harrod Blank unless credited below:

Pages 7 & 8	**Les Blank**
Page 10	**David Silberberg**
Page 12	**Bill Van Calsum** (center photo)
	Sam Zurik (right photo)
Page 13	**Bill Van Calsum**
Page 20	**Octavio Nuiry**
Page 22	**David Silberberg**

Page 28	**Liz Zivic** (right photo)
Page 29	**Liz Zivic**
Page 32	**Bob Rousseau**
Page 36	**David Besley** (left photo)
	Liz Zivic (right photo)
Page 37	**Liz Zivic**
Pages 40 & 41	**Gary Sutton**
Page 43	**Richard Harding**
Pages 54 & 55	© **Eric Staller**
Page 62	**Steve Saroff**
Page 69	© **Janice Rubin** (left photo)
Pages 70 & 71	**Liz Zivic**
Page 74	**Steven G. Thomas** (left photo)
	Don Heath (right photo)
Page 78	**Tom Hibschaman** (left photo)
	Sandy Agrafiotis (right photo)
Page 79	**Sandy Agrafiotis**
Page 80	**Liz Zivic** (top photo)
Page 81	**Liz Zivic**
Pages 84 & 85	**Joanne M. Johnson**
Pages 88 & 89	**Liz Zivic**
Pages 90 & 91	**Liz Zivic**